IMAGES
of America

GLEN ELLYN

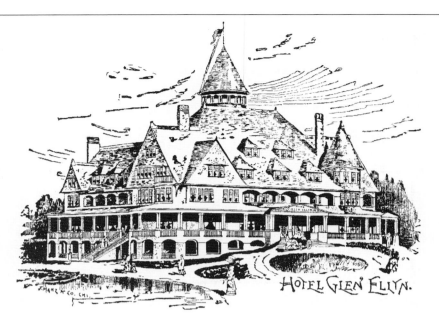

HOTEL GLEN ELLYN.

BUY A LOT OR AN ACRE AT

GLEN ELLYN

Before they get *ABOVE* your reach. $6 to $25 per front foot, *inclusive of street improvements*. There is *no other* spot in the *West* equal to this great property. Come and see and be convinced.

From the tower of *HOTEL GLEN ELLYN* you can see *Lake Michigan* and the *vast plain* upon which Chicago and *its suburbs stand*.

THINK OF IT!

FORTY-TWO MINUTES FROM WELLS STREET DEPOT TO GLEN ELLYN.

200 Feet Above Lake Michigan.

HILLS, FOREST, LAKE AND THE GREATEST GROUP OF MINERAL SPRINGS IN THE WORLD.

This property will *MORE* than *double* in value within *one year* and *will* reach $100.00 per foot *within 30 months*. We will show you these bargains any day free of expense (no Balloons or Brass Bands).

TERMS, ONE-HALF CASH, BALANCE DECEMBER 1st, 1891.

This 1891 advertisement appeared in national publications such as the *New York Times* and *The Ladies' Home Journal* to promote the new upscale lifestyle of Glen Ellyn. Property sold quickly because everyone knew that prices could only go up. And they did, until the panic of 1893 burst the bubble, and heavily mortgaged buyers lost everything. The good news was that Glen Ellyn real estate suddenly became much more affordable for new buyers.

On the cover: Many people still refer to the refrigerator as an "icebox." A century ago, every home had a real one, with space for a block of ice cut from a lake in winter, stored in an insulated icehouse, and delivered in an ice wagon like this. Before they became the village's first automobile mechanics, Herman and Otto Miller, shown here in front of Thomas E. Hill's home on Anthony Street, made deliveries for Jack Turner's Glen Ellyn Ice Company. (Courtesy of the Glen Ellyn Historical Society.)

IMAGES
of America

GLEN ELLYN

Russ Ward
with photographs from
the Glen Ellyn Historical Society

ARCADIA
PUBLISHING

Published by Arcadia Publishing
Charleston SC, Chicago IL, Portsmouth NH, San Francisco CA

Printed in the United States of America

Library of Congress Catalog Card Number: 2006924208

For all general information contact Arcadia Publishing at:
Telephone 843-853-2070
Fax 843-853-0044
E-mail sales@arcadiapublishing.com
For customer service and orders:
Toll-Free 1-888-313-2665

Visit us on the Internet at http://www.arcadiapublishing.com

For Ann Bailey Prichard (1900–2006)

CONTENTS

ACKNOWLEDGMENTS

The writer would like to acknowledge the invaluable assistance of the Glen Ellyn Historical Society's Archives and Historical Records group for providing most of the excellent images contained within this book. Special thanks to technology director Weldon Johnson, who provided digital copies of the images and to historian Bob Chambers for his help in research and fact-checking.

Special thanks to former historian Helen Wagoner Ward for her generous assistance and for providing many additional resources and images. With the assistance of her husband, Don Ward, Helen has spent countless hours over the past decades acquiring and cataloging images and oral histories for the society and, with Bob Chambers, compiling the excellent and comprehensive history *Glen Ellyn: A Village Remembered*, which is available for purchase from the Glen Ellyn Historical Society. Without her tireless efforts and careful preservation of the family collection, the society's archives would be considerably smaller. The author has attempted to compensate herein for Helen's modest restraint in her previous work in giving credit to the importance of the Wagoner family in the 20th-century history of Glen Ellyn.

Thanks to the Wheaton College Archives and Special Collections and to Arcadia editor Jeff Ruetsche for his help and for the opportunity to write this book. Thanks to the Glen Ellyn Historical Society for their dedication to the conservation of the homes and handiwork of Glen Ellyn's pioneers and preservation of the living history that endures in the endangered historic buildings and architecturally diverse neighborhoods. And to the Citizens for Glen Ellyn Preservation for promoting the radical concept that a well-built vintage home of moderate size just might represent the highest and best use of a residential lot in an established neighborhood.

And very special thanks to the lovely and talented Diane Ward, who has graciously suffered the absence of her husband for far too many hours.

INTRODUCTION

When Illinois joined the Union in 1818, Chicago was little more than a frontier fort and trading post. The rolling glacial moraines, fertile prairies, and old-growth forests that became DuPage County remained largely uncharted Native American country until 1832, when the capture of the great warrior Chief Black Hawk opened the way for settlement.

The Erie Canal and the Great Lakes soon brought droves of hardy New Englanders to settle the lands secured by the 1833 Treaty of Chicago. The United States government gave the Native Americans about 36¢ an acre for this real estate and offered it for $1.25 to settlers like Ralph and Morgan Babcock from Onondaga County, New York, who laid claim to a large wooded area some 20 miles directly west of Fort Dearborn.

Babcock's Grove lay on an ancient buffalo trail that led westward from the Des Plaines River in present-day Maywood to a shallow bend on the East Branch of the DuPage River where 500 Potawatomi still remained in a riverbank village. Here the Babcock brothers set aside a claim for their New York neighbor, Deacon Winslow Churchill.

Arriving with his large family in 1834, Churchill was the first white settler within the future borders of Glen Ellyn, and his crude log cabin was the first building. When Churchill's sons Seth and Isaac made the long journey back to Chicago to purchase necessary supplies, the tracks made by their heavy ox-drawn wagon turned the old buffalo trail into a direct westward extension of Lake Street in Chicago, a name that it bore until the mid-1920s.

When this new road was extended into the highlands west of the DuPage River and then on to St. Charles, it became a frontier highway for westward bound pioneers. The Potawatomi moved on, more settlers moved in, and a little New England–style community began to grow on a crossroad just up the hill from the Churchill settlement.

Within a year of the good deacon's arrival, William Dodge, brother-in-law to both Ralph Babcock and the deacon, settled to the south, Daniel Fish established a claim to the west, and a Massachusetts native by the name of Moses Stacy built a log cabin on a large parcel to the southwest. The families soon welcomed a circuit-riding Scotch-Irish preacher named Rev. James McChesney, and they built a log school that also served as a house of worship.

At Fish's cabin, the new road to St. Charles crossed an old trail known as Indian Creek Road (now Main Street), and yet another trail forked off toward Geneva, forming a five-cornered intersection. By the early 1840s, a village had formed around Fish's Corners, with several blacksmiths, wagon and harness shops, Milo Meacham's general store, and a little Baptist church.

Here Moses Stacy built a tavern to serve the now heavy commerce between Chicago and the Fox River valley. According to Amos Churchill, the traffic "was so dense that it was difficult

to cross the road". The community became known as Stacy's Corners, and the little triangular green between the church and the tavern (Stacy Park) began to serve as a town square.

The great Galena and Chicago Union Railroad opened in 1848 with the first 10 miles of track laid from Chicago to Maywood, bound for the lead-mining boomtown of Galena. The following year, the first locomotive passed through a sleepy little valley just a mile south of Stacy's Corners. The owner of the farm through which the tracks were laid believed that a passenger station might form the nucleus of a new town. Connecticut-born Dr. Lewey Quitterfield Newton, who owned most of what is now downtown Glen Ellyn, built a station complete with a freight platform and a water tank. The trains stopped and the people came.

<div align="center">***</div>

New communities blossomed along the railroad tracks, including one that formed around Newton's Station, renamed Danby in 1852 by the first station agent, David Kelley. While the railroads brought great wealth and development to Chicago, they extinguished Galena's river-based economy, and as the heart of Danby's downtown shopping district grew, Stacy's Corners suffered the same fate.

Across from the new station, Kelley built a three-story hotel called Mansion House in which he also opened the first post office. Milo Meacham of Stacy's Corners built the nearby Danby House, which hosted the Reverend McChesney's Sunday school. A general store, a shoemaker, and a tin shop opened on Main Street, and on Pennsylvania Avenue, a blacksmith and harness shop appeared, along with an old-fashioned Dutch windmill.

The trains brought scores of new residents to the growing town, including L. C. Cooper, who ably chronicled the formative years of the village, but they also brought news of storm clouds gathering on the horizon.

Glen Ellyn's political roots date back to the days when the Republican Party was founded to oppose the expansion of slavery into the new western territories, an issue that was hotly debated in political meetings held in the Danby House. Cooper recalled one meeting in which a visiting black orator castigated the Buchanan administration for its condescension to Southern demands. When he asked if anyone in the room would vote to reelect James Buchanan, only one farmer, an active Democrat, said that he would.

Cooper illustrated the local attitude toward slavery with this story:

> I was sitting on the veranda of the Mansion House, talking with "Deac" Whitman [who] walked with great difficulty and with the aid of crutches. While his legs were of little use, he was very strong in the upper part of his body, especially in his arms and shoulders.
>
> While we sat there, a colored man came along and asked for a drink. He was told to help himself and as he was doing so, two men drove up. As soon as the black man saw them he left the pump and came to where we were sitting. It became apparent that he was an escaping slave and that the two men were in pursuit of him.
>
> "Deac" rose from his chair, grabbed the black, jerked him into the doorway, braced himself against the side of the door and began such a cursing and denunciation of the two men as I never heard before or since. He dared them to come near enough to enable him to get his hands on them, threatening to tear them to pieces.
>
> The men were not equal to the emergency and so returned to their buggy and drove away. As soon as they were out of sight, the runaway slave was so directed as to avoid pursuers and continue his journey to a land of freedom.

Danby folks "wept over the sorrows" of *Uncle Tom's Cabin*, which was popularly performed as a play. Author Harriet Beecher Stowe, quoted in 1875 by the *Wheaton Illinoian*, said that Emmiline Hall, who lived in Glen Ellyn's traditionally "colored" west side neighborhood along Hill Avenue, was the model for the character of Simon Legree's slave concubine Emmiline: "She and her sister were taught in a private school kept by my own family for the benefit of my

children. . . . many of the little incidents I got from her mother who . . . had been at night, as Cassy did, to wash the wounds of the slaves suffering under the lash."

Danby was home to a major Underground Railway station and many unsung heroes of a war in which roughly one in a dozen of America's able-bodied men died. No family was untouched. And while the postwar years brought prosperity to the industrial northeast, Midwestern farming villages like Danby suffered from massive inflation caused by the printing of paper money to finance the war.

After the grateful cheers had faded, the soldiers who had fought the bloodiest war in our nation's history found life in the quiet village stifling. L. C. Cooper illustrated the problem with an account of some Danby veterans who had learned clog dancing from the liberated slaves in the South. They had also learned how to fight, both skills serving them well at the popular country dances:

> In those days our county was well supplied with lager beer, as a result these dances too frequently ended in a very boisterous manner. The young men referred to generally attended. Their popularity with the young ladies, enhanced by their dancing abilities, did not please some of the other males and the feelings engendered soon manifested themselves in unpleasant remarks. The result generally was that our boys "cleaned out the house". Danby soon began to suffer in reputation as a rowdyish town.

Cooper told of another blow to Danby's reputation that came from an exchange between a train conductor named Bross and a very drunk passenger:

"After giving the fellow a vigorous shaking Bross said to him, 'Tell me, where are you'n going?' and all the reply was, 'Hell'. Bross thought a moment and said, 'Well, if you're going there, I'll put you off at Danby'. Some of our friends from neighboring towns heard this and, of course, made the most of it."

Danby's reputation was tarnished by more than drinking and brawling. One outspoken old-timer maintained that it was a well-known "brothel town," with three hotels doing a thriving business on Saturday nights. The people attempted to reinvent the community with a more pleasant and forward-looking image by changing its name to Prospect Park, but real change did not come until "Professor" Thomas E. Hill built his luxurious home in the wooded highlands, a half mile south of town.

Hill recognized the potential for real estate development, targeting upper-middle-class Chicagoans who wanted to raise their families away from the grimy city where they worked. He envisioned a suburban lakeside resort community with a hotel and mineral springs, and he soon convinced others to invest in his idea.

Several spring-fed streams ran through the village into a marshy basin that would form the centerpiece of Hill's planned development. His partnership bought options on the gently sloping woodlands on the west side of this "glen," and they raised a dam across its northern outlet, thus creating the picturesque Lake Glen Ellyn. In 1891, when the community officially adopted the name Glen Ellyn, village president Thomas E. Hill's vision was realized.

A spectacular grand hotel overlooking the lake was built, and pristine mineral springs were conveniently discovered nearby. The luxurious and healthful lifestyle offered by this new upscale resort led to a Victorian building boom that defined the architectural character of the village. Thirty of the first 50 historic homes that were "plaqued" by the Glen Ellyn Historical Society were built between 1890 and 1896.

At the end of the 19th century, the future looked bright for this uniquely beautiful village, described in the *Wheaton Illinoian* as "one of the most picturesque and charming localities in the whole West." But the saloons were still thriving, and within just a few years, the resort had failed, the hotel was gone, and Glen Ellyn would have to reinvent itself once again.

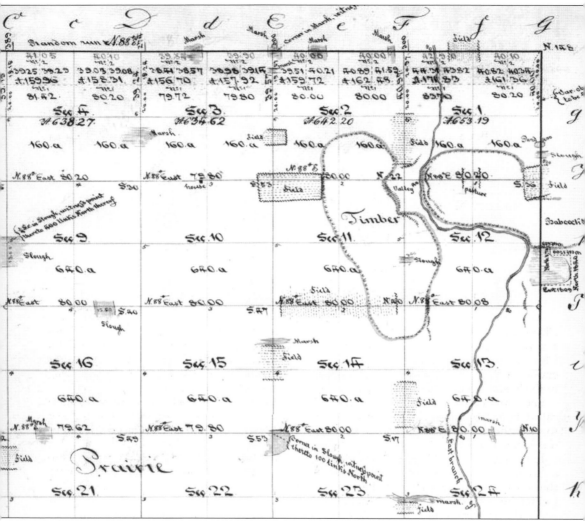

This 1842 plat of survey shows part of Milton Township at the time of settlement. Each section is a square mile. Most of downtown Wheaton now lies within Section 16 at the lower left, while downtown Glen Ellyn is located in the west half of Section 11, between Moses Stacy's "Field" on the north and Lewey Newton's on the south. Lake Ellyn lies just east of the center of Section 11, in the midst of the "Timber" that stretched from present Highview Avenue on the south to the old Great Western tracks on the north. The wooded area northeast of the bend in the river, where the Churchills first settled, is identified here as Babcock's Grove. The "Marsh" in the northwest quarter of Section 14 was made into a lake by Thomas E. Hill in the late 1880s, and the "slough" in the northwest corner of Section 23 now hosts the Village Links clubhouse.

One

A Wilderness Transformed

Chicago was home to just 350 hardy souls when the Babcock brothers laid claim in 1833 to a grove of oak trees that included the northeast part of Glen Ellyn. Pioneer Isaac Bradford Churchill described the Chicago prairie east of present-day Oak Park to his son Amos: "It was covered with water and above the water was prairie grass and wild flowers were in bloom, waving in the breeze." Today that windswept prairie is known as Chicago's West Side.

Encompassed by miles of uninhabitable marshland and safeguarded by a frontier stockade called Fort Dearborn, Chicago served primarily as the gateway for Eastern farmers eager to stake their claims in the newly opened northern Illinois wilderness. But that would change soon enough.

In the space of just 20 years, early Glen Ellyn evolved from Potawatomi hunting grounds into a thriving farm town on the main line of the new Galena and Chicago Union Railroad. During that brief time, it was known as the western part of Babcock's Grove, Fish's Corners, DuPage Center, Stacy's Corners, Newton's Station, and Danby.

As the frontier shifted ever westward, the pioneering New England settlers welcomed European craftsmen, sturdy farmworkers, and enterprising merchants to this new Midwestern community. They also harbored the desperate refugees of a growing internal struggle between the increasingly industrial North and the plantation-based Southern states. A commercial and residential district formed around the new railroad station while most of what is now known as Glen Ellyn remained farmland in the hands of the founding families: Churchill, Ackerman, Christian, Stacy, Dodge, and Newton.

Photographs were rare in those days, and painted portraits were expensive. The best available images of the original buildings are from sketches that lined the old subscription-based farm atlases, such as one compiled in 1862 by county land surveyor Horace Brooks of Danby, who served with distinction in the Civil War. These and the few photographic images that remain help us to appreciate the challenges faced by the early pioneers and to picture the village as it was in the early days.

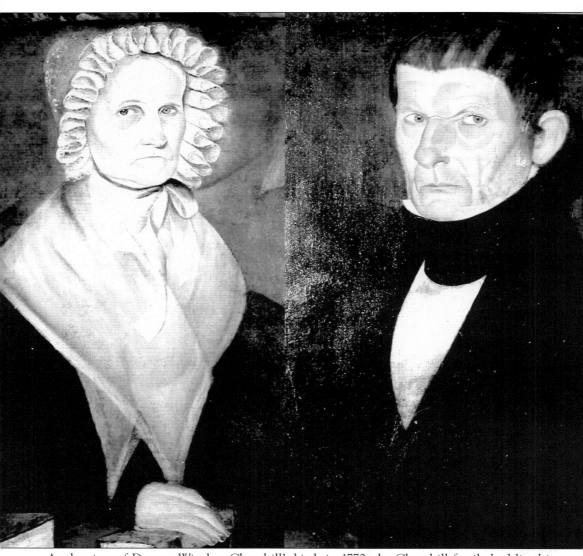

At the time of Deacon Winslow Churchill's birth in 1770, the Churchill family had lived in Plymouth, Massachusetts, for 127 years. Winslow's father fought in the Revolutionary War, and his mother was a direct descendant of Gov. William Bradford. In 1796, Winslow married Mercy Dodge, the daughter of another Revolutionary War soldier, and eight years later, they bought a 100-acre farm near Onondaga, New York, where Winslow earned his living as a farmer and stone mason and earned the title of deacon. He operated a boat on the Erie Canal, which was dug straight through his farm in 1825. At the age of 64, the deacon packed up his wife and 11 grown children and their families for the journey down the canal to Buffalo, where they boarded a steamer bound for Chicago and the wilds of northern Illinois. These portraits are attributed to local educator, abolitionist, and folk artist Sheldon Peck.

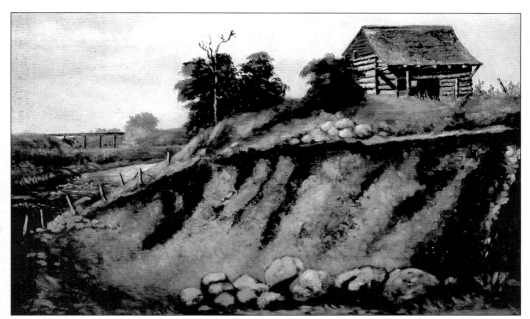

Winslow Churchill built this log cabin in 1834, overlooking a Potawatomi village in what is known today as the Churchill Forest Preserve. In the 1890s, artist and historian Ada Douglas Harmon made this painting of Glen Ellyn's first structure with the new Great Western Railroad bridge visible in the background. The cabin survived until the end of the 19th century when the moraine on which it stood was mined out for gravel.

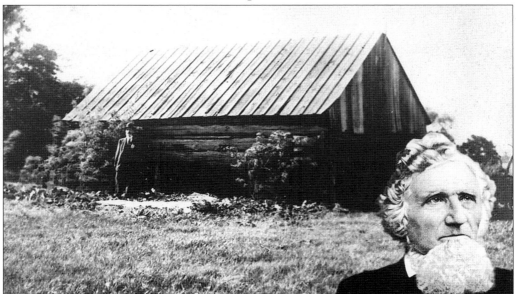

Seth Churchill (inset) was 29 when he arrived in Babcock's Grove with his family. His log cabin, erected soon after his father's, stood for more than a century on St. Charles Road. In its time, it served as a dwelling, a tavern, a school, and a church. His son William H. Churchill stands in front of the cabin, which was donated to the Daughters of the American Revolution in 1928 but not preserved.

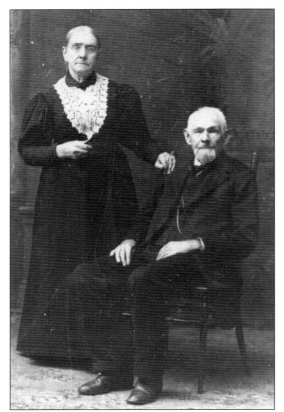

Only 16 when he arrived, Isaac Bradford Churchill married Angeline Barker in 1841 and became a prosperous farmer. Amos Churchill, the celebrated Civil War veteran and builder, was their eldest son. In 1846, they established their farm on 230 acres. Located on Swift Road between St. Charles Road and North Avenue, the farmstead is still occupied by his descendants. Much of the acreage was sold or donated for the construction of North Avenue and the Commonwealth Edison substation. This drawing of the still-occupied farmhouse is from an 1874 atlas of DuPage County.

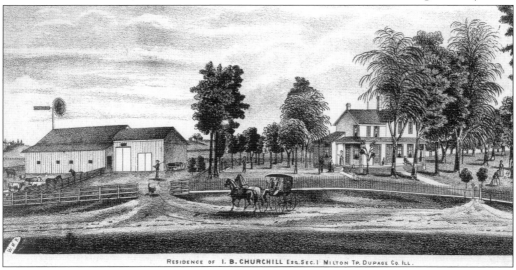

RESIDENCE OF I. B. CHURCHILL Esq. Sec. 1 Milton Tp. DuPage Co. Ill.

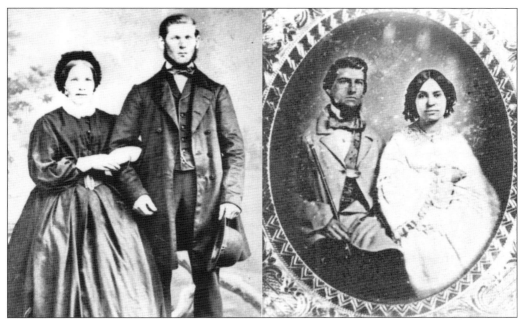

Winslow Churchill's daughter Christiana was widowed with one child, Erastus Ketcham, and remarried to David Christian (left) before they came to Illinois. Christiana's twin sister Lurania was accompanied on the journey by her husband John D. Ackerman (right) and their three children. John was an expert trapper and Lurania wove the fabrics for the Churchill family clothes on a loom she carried from their home in New York. Their cabin, with additions and clapboard siding, still stands on the south side of St. Charles Road just east of the corners. In 1893, Christiana (below, left) and Lurania, born in 1802, were nationally recognized as the oldest twins in the United States.

Erastus Ketcham was eight when he arrived at Babcock's Grove with his mother. He became a carpenter and a legendary trapper who, according to Ada Douglas Harmon, "hunted fur-bearing game where the city of Chicago is spread. He was a friend of the Indians, his life being saved at one time by them. He had a wonderful soprano voice . . . soaring quite above the singing of the whole congregation. Everybody called him 'Old Ketch.'"

Another colorful pioneer character, Alonzo Ackerman was born to Lurania Churchill Ackerman four years after they arrived at the DuPage River. After he returned from the Civil War, according to Ada Douglas Harmon, "he wore his hair in long curls falling over his shoulders. Annually on his birthday it was clipped, the occasion being a great event."

The first recorded wedding occurred when the settlement was known as Fish's Corners. Gilbert Way, pictured here with his remarkable sideburns, married Harriet Fish in April 1840. According to L. C. Cooper, the ceremony was performed by a laconic fellow named Hatch as follows: "I have had no experience but I understand that I have the authority as justice of the peace under the laws of Illinois to officiate, so I pronounce you husband and wife."

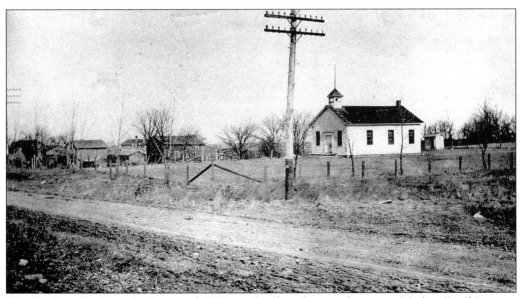

The first log school was built around 1836 on what later became known as Madam Rieck's estate on Riford Road. The frame schoolhouse pictured above served the Five Corners community from 1859 until 1910, on the present site of the School District 41 offices at Main and Elm Streets. That little strip of dirt road in the foreground is Main Street, and the empty field to the left of the school now hosts the White Hen Pantry.

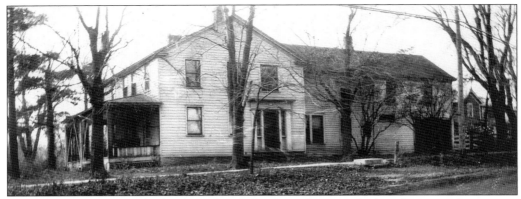

Stacy's 1846 tavern was built of wood with bricks and mortar laid up between the exterior framing. Moses and Joann Stacy offered food, drink, and lodging for weary travelers on the new State Road from Chicago to the Fox Valley and points west. Supper, a bed, breakfast, and hay for two horses could be bought for 50¢. Philo Stacy reported that Native Americans were frequent overnight customers with as many as 2,000 making camp on the grounds at one time.

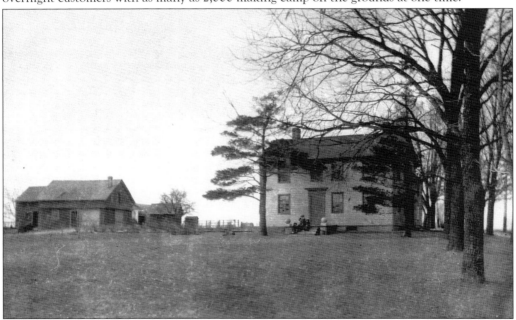

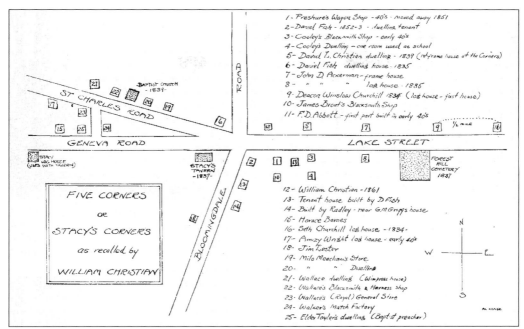

The map labels read:

1 - Preshure's Wagon Shop - 40's - moved away 1851
2 - Daniel Fish - 1852-3 - dwelling, tenant
3 - Cooley's Blacksmith Shop - early 40's
4 - Cooley's Dwelling - one room used as school
5 - David T. Christian dwelling - 1839 (1st frame house of the Corners)
6 - Daniel Fish dwelling house - 1835
7 - John D. Ackerman - frame house
8 - " " " log house - 1835
9 - Deacon Winslow Churchill 1834 (log house - first house)
10 - James Brout's Blacksmith Shop
11 - F.D. Abbott - first part built in early 40's

BAPTIST CHURCH -1839-
ST CHARLES ROAD
GENEVA ROAD
ROAD
LAKE STREET
STACY'S TAVERN -1837-
STACY LOG HOUSE (used with tavern)
FOREST HILL CEMETERY 1837
BLOOMINGDALE

FIVE CORNERS
or
STACY'S CORNERS
as recalled by
WILLIAM CHRISTIAN

12 - William Christian - 1861
13 - Tenant house built by D. Fish
14 - Built by Radley - near G.M. Griggs house
15 - Horace Barnes
16 - Seth Churchill log house - 1834 -
17 - Amziy Wright log house - early 40's
18 - Jim Lester
19 - Milo Meacham's Store
20 - " " Dwelling
21 - Wallace dwelling (Wimpress house)
22 - Wallace's Blacksmith & Harness shop
23 - Wallace's (Royal) General Store
24 - Walker's Match Factory
25 - Elder Taylor's dwelling (Bapt'st preacher)

William Christian (1836–1926) was the youngest son of David and Christiana Churchill and half brother to Erastus Ketcham. This early map of the town where he grew up, though not entirely accurate, is based on his recollection at the end of his long life. Note that St. Charles Road, east of the corners, was known as Lake Street, and Main Street was called Bloomingdale Road.

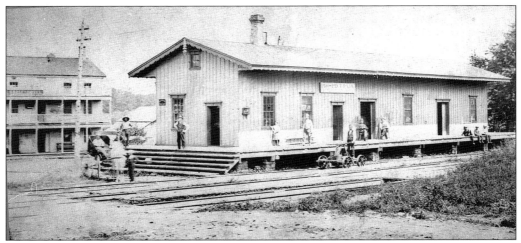

The first railroad station built by Dr. Lewey Quitterfield Newton on his farm was soon moved across the street where it became the shop and residence of Mr. Gates the shoemaker. The railroad then built this larger station complete with an agent's office and freight warehouse. This station house, which stood on the southeast corner of Crescent Boulevard and Main Street until 1895, bore the names Danby, Prospect Park (as in this photograph), and finally Glen Ellyn.

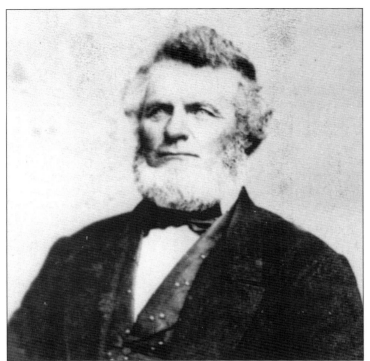

In 1851, stationmaster David Kelley renamed Newton's Station after his birthplace of Danby, Vermont. David was the brother of Daniel Kelley, who became known for the fine merino sheep that he raised on his estate on St. Charles Road north of Wheaton, now an industrial park.

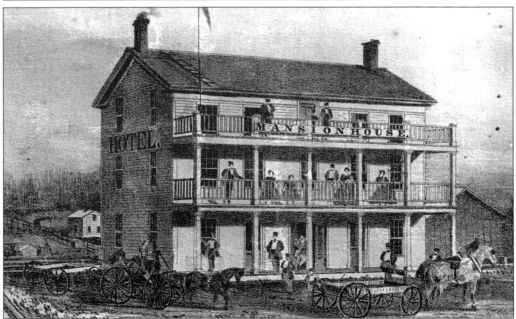

Justice of the Peace David Kelley also served as the first postmaster at Danby. The following year, he built the three-story Mansion House hotel across the street from the station, on the northeast corner of Main Street and what is now Crescent Boulevard. This image is from the 1862 Brooks map of DuPage County. Part of the building is visible in the photograph of the railroad station on page 19.

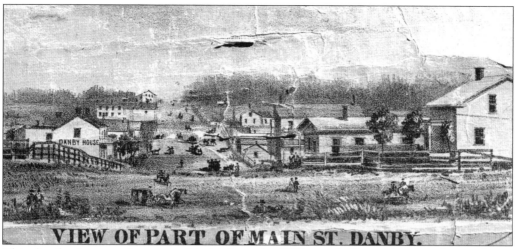

VIEW OF PART OF MAIN ST. DANBY.

This sketch of prewar downtown Danby from the 1862 map looks north across Duane Street from the Horace Brooks farm where Main Street began. On the right is the Henry Benjamin house, the second railroad station, Mansion House, and the homes of Albert S. Janes and Miles Allen. On the left is the original two-story Danby House, the Charles Cooper and DuBrock stores, John Sabin's home, and the William Freeto house and store at the top of the hill. The edge of the great grove of trees that extended to the DuPage River and beyond can be seen in the background.

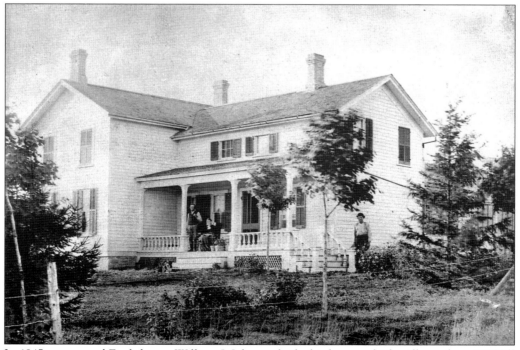

In 1845, one-armed Englishman William J. Johnson built this home, which still stands at 426 Hill Avenue, formerly known as Gardner Bridge Road. Johnson served as county treasurer and reportedly owned Danby's first lumberyard where the present train station is located.

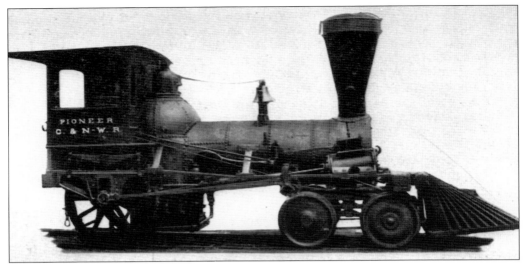

The first locomotive to steam its way from Chicago through Dr. Lewey Quitterfield Newton's farm in 1849 was the appropriately named *Pioneer*. Built in New York in 1843, and used in the construction of its own track all the way to the Mississippi, this veteran iron workhorse is now on display at the Chicago Historical Society.

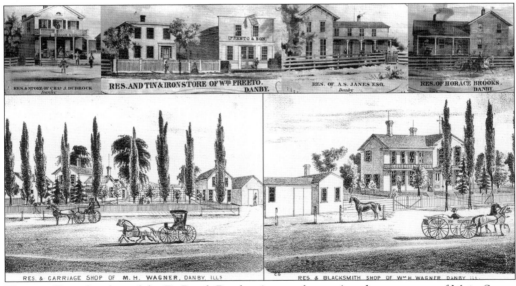

The excellent sketches of the DuBrock Brothers' general store (southwest corner of Main Street and Pennsylvania Avenue), William Freeto's home and tin shop (southwest corner of Main and Anthony Streets), and the homes of A. S. Janes (east side of Main across from DuBrock's) and Horace Brooks (west side of Main, south of Duane Street) are from the 1862 map. A county atlas published in 1874 provided the views of the Wagner carriage and blacksmith shops that stood on the north side of Pennsylvania Avenue, between Glenwood and Prospect Avenues. None survive.

Two

The Civil War Years

L. C. Cooper was six years old when stationmaster David Kelley welcomed his family to Danby in 1852. Seventy years later in a *Glen Ellyn News* column entitled "Reminiscences of Old Glen," Cooper provided a delightfully personal firsthand account of the early history of the village.

Cooper grew up along with Danby in the decade leading up to the Civil War, reaching the age of enlistment just as it ended. During the long war years when most able-bodied men were gone and the townspeople were consumed by fear for their loved ones, Cooper read the war dispatches to the anxious families at the Mansion House. His father Charles, along with David Kelley and old Mr. Gates the shoemaker, trained the young recruits for service.

Before the Rev. James McChesney's son Joseph enlisted, he opened a modest grocery store on Crescent Boulevard that is now DuPage County's oldest continuously operating retail business. After L. C. Cooper's future father-in-law, Deacon Jonathan P. Yalding, declared that he would not raise his children in a village "where there was no church, only saloons and houses of ill repute," a Congregational church was organized. But foremost in everyone's minds was the terrible war and the brave volunteers for which Cooper expressed his boundless admiration:

"No braver, more heroic patriots ever fought for their country than the Danby boys. A distinguished officer in the Army of the Potomac declared: 'Give me a regiment like Frank Meacham and I could capture Hell, and then give me another regiment like Horace Brooks and I could hold it throughout eternity!'"

Cooper also told the story, related in the introduction to this book, of a runaway slave who was defended by an unlikely hero at the town pump on the veranda of the Mansion House. The place of refuge the man was directed to find lay just a mile east down Crescent Boulevard at the Filer farm.

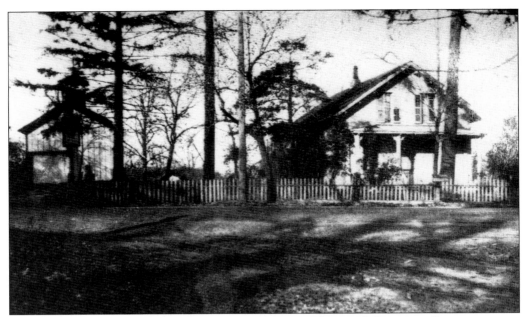

This sturdy house on Crescent Boulevard, built in 1852 by local abolitionist Thomas Filer, was a well-known station of the Underground Railroad. Filer received the fugitives from Wheaton and concealed them in the little barn that he built for this purpose. A hidden tunnel connected the two buildings, which were identified as an Underground Railroad station and a valuable "link to the past" by Ada Douglas Harmon in 1928 and again by Frederick S. Weiser in his excellent 1957 history *Village in a Glen*. But these eminently historic structures were demolished in the 1960s to make room for upscale homes overlooking the DuPage River and the Churchill Forest Preserve.

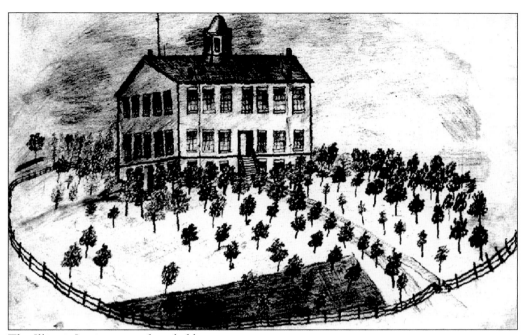

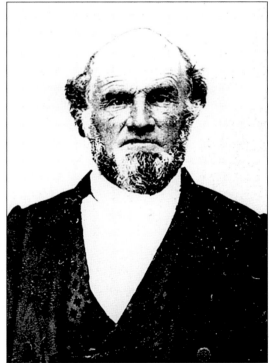

The Illinois Institute was founded by the antislavery Wesleyan Methodists in 1853, about a mile and a half west of the Danby train station. One of the most prominent and outspoken of the Wesleyan abolitionists was founding president Lucius C. Matlack, who is said to have made the school a station on the Underground Railroad and who later joined the Union Army along with 67 of his former students, many from Danby. In 1859, the presidency was assumed by abolitionist Rev. Jonathan Blanchard (seen here), who renamed the school Wheaton College after a local benefactor. Escaped slaves reportedly arrived here concealed under the contents of farm wagons and were offered safe harbor until they could be transferred to the Filer house and then on to Chicago, where they would board ships bound for Canada. (Courtesy Wheaton College Archives and Special Collections.)

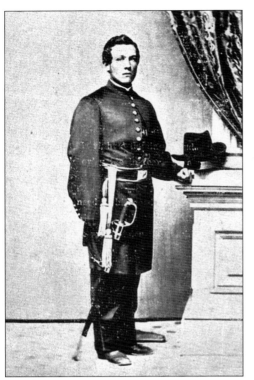

Isaac B. Churchill's son Amos was one of the Wheaton College students who enlisted in 1861 along with Illinois Institute president Lucius C. Matlack. His daughter Adeline wrote that Churchill "was made Lieutenant in the 8th Illinois Cavalry. In the battle of Antietam, after having three horses shot out from under him, he was severely wounded. His arm was saved from amputation, but the elbow joint was taken out. He resumed his studies until re-enlisting the next spring for 100 days service. Again came study and again the next spring he raised a company and took them to camp, but on account of his arm, he was not accepted."

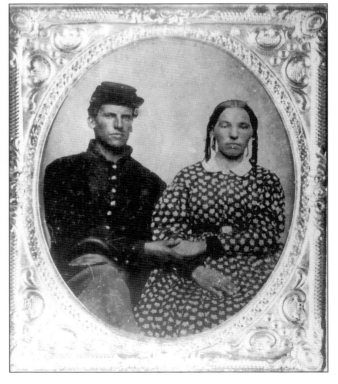

Pioneer trapper Alonzo Ackerman of the 105th Illinois Infantry poses in uniform with his German wife, Mary Coffin. In later years, they managed the County Farm, last home of the destitute and the infirm, now the DuPage Convalescent Center and the site of the county courthouse and administration complex.

Marcellus Ephraim Jones's wife died in childbirth along with their baby son after a fire destroyed his northern Wisconsin woodworking business. In 1858, the penniless but undaunted Vermont native moved to Danby, where he became a prominent building contractor. He enlisted in the 8th Illinois Cavalry, of which the Rev. Lucius C. Matlack was chaplain. In the early morning hours of July 1, 1863, Jones, in charge of a post in southern Pennsylvania, spotted the enemy advancing on a stone bridge: "Asking Sergeant Levi Shafer of Naperville for his carbine, I took aim at an officer on a horse and fired." A monument carved from Naperville granite marks the spot where Jones used a borrowed rifle to fire the opening shot at the Battle of Gettysburg. After the war, Jones and fellow Danby veteran Amos Churchill stormed the county courthouse at Naperville, stole the record books, and brought them to Wheaton, where Jones was later elected DuPage county sheriff and where his home is lovingly preserved by Peregrine, Stime, Newman, Ritzman and Bruckner. Jones is third from the left in this photograph, accompanied by Amos Churchill (far left) and William H. Luther (right).

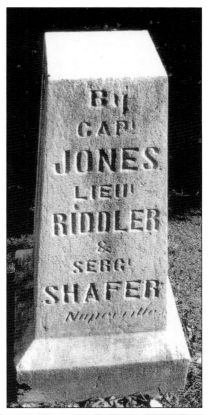

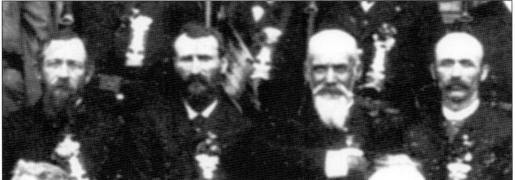

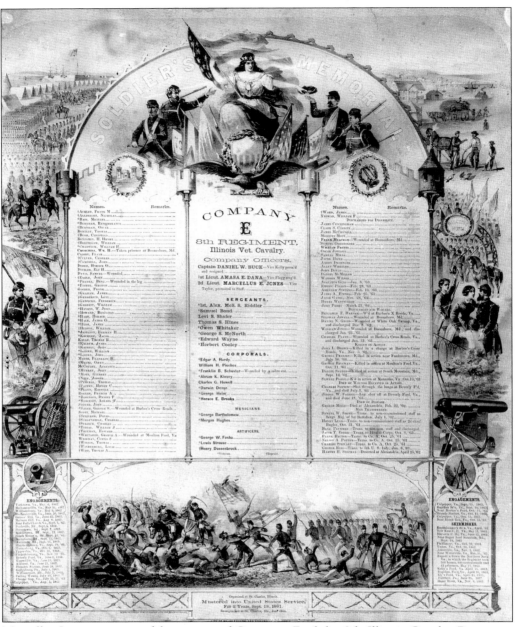

Marcellus Jones was second lieutenant of Company E of the 8th Illinois Cavalry Regiment. Among the many other Danby names that appear on this memorial presentation for his unit are Dodge, Churchill, Meacham, and Freeto. Composed primarily of DuPage County volunteers, the 8th Illinois was engaged at Antietam, Fredericksburg, Chancellorsvlle, and Gettysburg. Confederate colonel John S. Mosby, of the feared partisan guerilla battalion known as Mosby's Rangers, called the 8th Illinois "the best cavalry regiment in the Army of the Potomac."

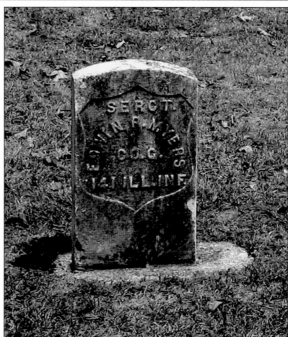

The home of William Henry Myers, who had a meat market in the Danby House, stood at the southwest corner of Pennsylvania and Prospect Avenues. He and his brothers Ed, Charley, and police chief Fred Myers all fought in the Civil War and all rest in Forest Hill Cemetery, under marble gravestones like this. According to Ada Douglas Harmon, their father, Frederick A. Myers, who served at Fort Dearborn, "was a man of much learning for those days, speaking seven languages . . . a fur trader among the Indians for many years, he translated the Ojibwa language, making a dictionary with the English equivalents. He bought much property in Chicago, once owning the site of the court house. He died in Chicago and was buried in the old cemetery on the shore of the lake, now Lincoln Park."

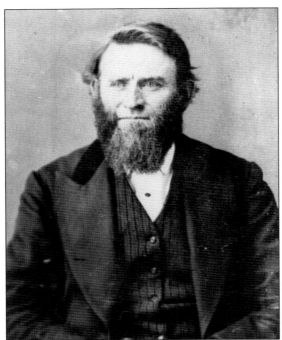

Philo Stacy was 16 when his father, Moses, built a tavern at the corners that would bear his name. A farmer on 500 acres of what is now prime Glen Ellyn real estate, Philo married the daughter of Rev. Philander Taylor and served in the 108th Illinois Volunteer Infantry during the Civil War. Philo's older brothers both died young, as did his own eldest son and daughter. Carrie Stacy, his youngest, never married.

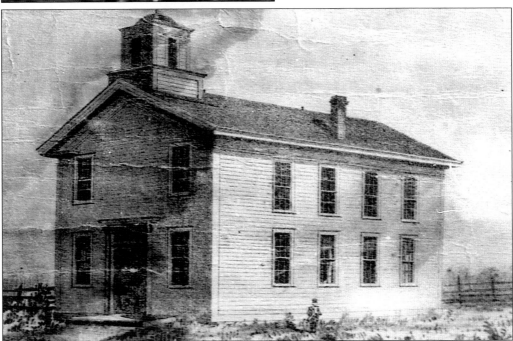

The first schoolhouse in Danby was built in 1853 on Duane Street just east of Main Street where the magnificent 1929 junior high school building now houses the Glen Ellyn Civic Center. Henry Benjamin was the first schoolmaster. In 1862, it was replaced by this larger structure, which was in turn moved in 1892 to the north side of Crescent Boulevard, just west of Park Boulevard, where it stood until the late 1950s.

Capt. Albert S. Janes came to Babcock's Grove with his family in 1835. He was appointed postmaster in 1861, and his wife took his place while he served his country during the Civil War. Afterward Janes served as justice of the peace and helped to plat the town as a surveyor. This home on the southeast corner of Main Street and Pennsylvania Avenue, built by Janes in 1856, served as a post office during the Civil War and was home to the McChesney family in the 1870s. It stood on the southeast corner of Main and Pennsylvania, across from the current post office.

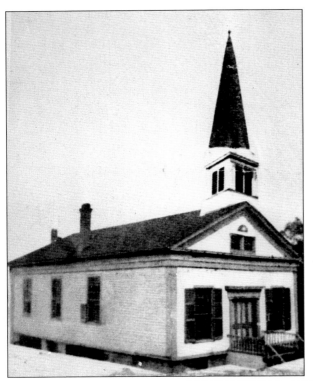

The newly organized Congregational Church of Danby purchased the Stacy's Corners Baptist Church building in 1862 and moved it down to the east side of Main Street in the center of town where they later added a steeple. The building began to pick up speed as it descended the hill, and Deacon Jonathan P. Yalding, an early Stacy's Corners pioneer, bravely stood in its path. His valiant but comically vain attempt to slow the building's descent became a local legend. Deacon Yalding brought this melodeon with him from New England. The little foot-powered reed organ was long the only keyboard instrument in town. The deacon would carefully disassemble it and carry it on his back to play at services in the little Congregational church. It is now in the collection of the Glen Ellyn Historical Society.

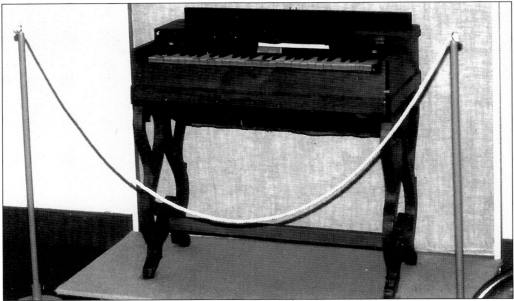

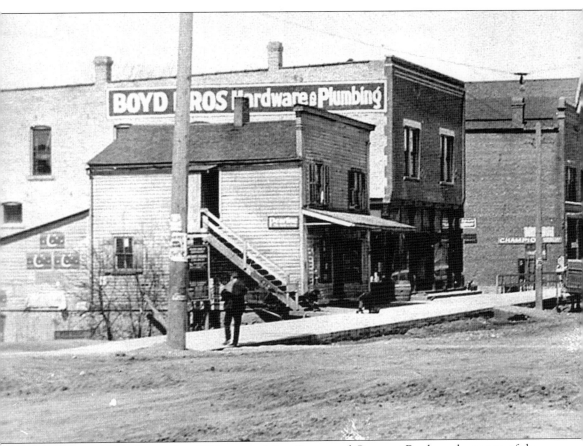

Seen here in 1906, this modest 1852 store at Main Street and Crescent Boulevard was one of the first businesses in Danby, operated by schoolteacher Henry Benjamin and his partner Mr. Rees. In the years leading up to the Civil War, it was occupied by the Cooper family. L. C. Cooper recalled an incident the day after the first battle of Bull Run when his father expressed his sorrow for the fallen Union soldiers to a man across the street, who "expressed his pleasure and declared it served them right. Harsher words were spoken and [my father] soon had the 'copperhead' by the collar and on demand a retraction and apology were made." The Copperheads, or Peace Democrats, held that Pres. Abraham Lincoln had violated the Constitution in pursuit of an illegal war that could not be won.

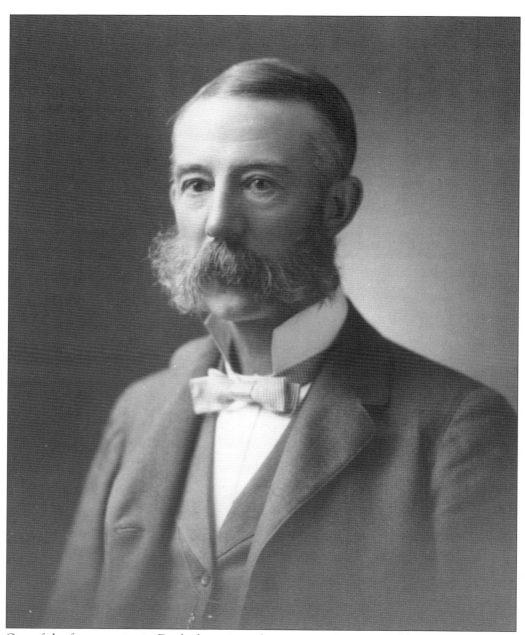

One of the first to arrive in Danby by train and to commute by train to Chicago, Lawrence C. Cooper served as local attorney for the railroad, state's attorney for DuPage County, and president of the Prospect Park Improvement Association, which created Lake Glen Ellyn. He was also a first-class storyteller who provided a wealth of colorful anecdotes in a series of newspaper columns that he wrote in the last year of his life. He commuted daily to his office in the brand-new Chicago Insurance Exchange Building. When the little store where he had lived during the Civil War was torn down in 1911, he wrote: "Many an old landmark in the city of Chicago has been ruthlessly removed to make way for something 'up to date'. An old landmark has just been removed in Glen Ellyn."

Three

THE DISPIRITED DECADES

Danby struggled to establish its identity in the postwar years. Once seriously considered as the seat of county government, Danby instead helped to establish the new courthouse at Wheaton, which quickly became a center of commerce and culture while Danby remained a quiet and rather shabby little farm town.

Danby residents witnessed the nocturnal glow of the Great Chicago Fire of 1871, and they felt the pinch of economic recession in the following years. Business improved only for the saloons. The scars of the Civil War upon so many local veterans and their families were slow to heal, but the ex-soldiers found solace in their own company. In 1878, Philo Stacy hosted a grand reunion for his own 108th Volunteer Infantry and the renowned 8th Illinois Cavalry in the oak grove across from his home on Main Street, complete with music, banners, and a tightrope walker who unfortunately fell to his death in front of the stunned crowd.

Dr. Lewey QuitterfieldNewton established a lumberyard next to Mansion House and station agent William H. Luther started a small feed business in the freight room of the depot. Luther entered into a partnership with fellow veteran Amos Churchill, who, along with the recently arrived Boyd Brothers, began building new houses throughout the town.

L. C. Cooper, who had played baseball while attending the university at Ann Arbor, organized a team he very appropriately named the Rustics. Their ball field was located in the old meadow that lies beneath Lake Ellyn. Cooper succeeded in drawing the barnstorming Chicago Excelsiors to a game with the Rustics, most of whom had never even seen real baseball played. The match, widely covered by the Chicago newspapers, not unexpectedly ended with a score of Chicago 102 Danby 2.

But growth was on the horizon. The pioneer families optimistically changed the name on the railroad depot to Prospect Park, and they began to subdivide their fields and groves. The town's population doubled to 600 as graveled roads, wooden sidewalks, and gaslights began to appear. The newly incorporated village's first telephone was installed in the McChesney store in 1885, and the suburban character of the community slowly began to take shape.

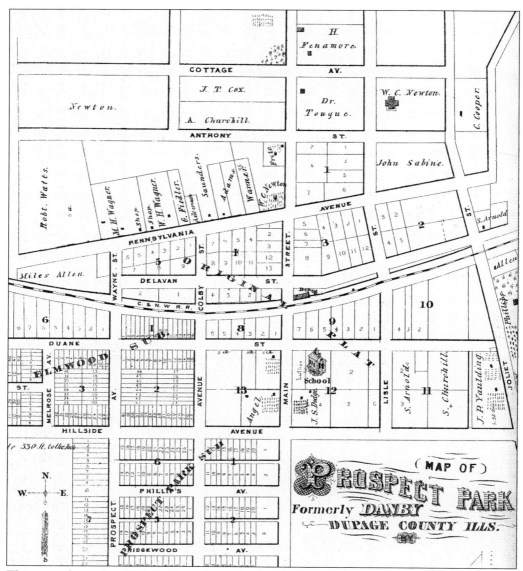

(MAP OF) **Prospect Park**
Formerly **DANBY**
DUPAGE COUNTY ILLS.

This map from the 1874 DuPage County atlas shows the newly christened community of Prospect Park in transition. Everything north of Phillips Avenue and west of Joliet Street (Park Boulevard) originally belonged to Dr. Lewey Quitterfield Newton, whose $200 purchase of 160 acres in 1842 has appreciated considerably. Philo Stacy's farm lay on the north side, and the old grove filled the eastern landscape. The proposed subdivisions on the southwest side existed only on paper for many years yet (see page 78). Delavan Street later became Crescent Boulevard, and Lisle Street became Forest Avenue; Pennsylvania Avenue and Joliet Street actually both ended where they intersect, with nothing to the east but a creek running through a wooded ravine. L. C. Cooper later extended Park Boulevard with a gentle curve from Anthony Street to Pennsylvania Avenue, and the ravine east of his home, known as Sleepy Hollow, became Deerpath Road, where the author grew up.

36

The town that had helped so many escaped slaves on their way to freedom now welcomed Charles and Mary Beaner as residents. An ex-slave and Civil War veteran, Charles is remembered as the town's first ice-cream vendor. Ruth Gordon LePage remembered listening to Mary Beaner's stories on the porch of their house at 478 Pennsylvania Avenue, a recent teardown replaced by an office building with the same address. They rest in Forest Hill Cemetery.

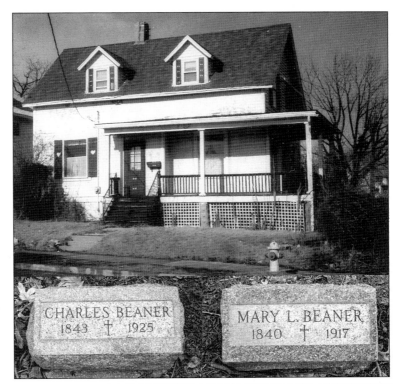

Grocer Joseph R. McChesney was appointed postmaster and first president of the Village of Prospect Park. He was joined in business by his sons in 1878 when they built this little frame grocery store on the east side of Main Street next to the Mansion House. In 1892, when Dr. James Saunders moved the old Congregational church building, the McChesneys relocated their store onto the former church site and built the new brick building seen above on the right, still standing today.

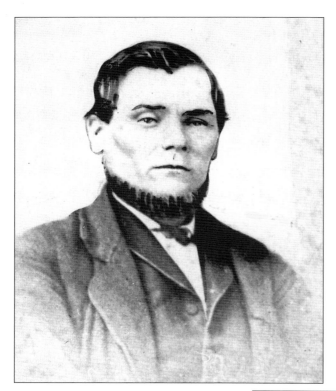

Born in 1830, Walter Sabin was among the first teachers at the new Danby School on Duane Street, commonly referred to as Sabin's School. L. C. Cooper was one of his students: "Small of stature, awkward and ungainly in appearance, handicapped by the loss of an eye, not having had the advantages derived from collegiate training . . . nevertheless by his splendid tact, devotion to his calling and his constant enrichment of his mind, he was enabled to win and hold to the end . . . the respect and esteem of the entire community."

Georgia B. Allen, one of Walter Sabin's star students, lived where the post office now stands and taught for three decades in the old frame Duane Street School and the masonry building that replaced it in 1892. Like Sabin, Allen had limited higher education, one blind eye, and the love and respect of the community. Allen was a founding member of the Utili Dulci Society.

In collaboration with Sabin's School, the little Congregational church on Main Street provided a somewhat more wholesome sort of entertainment for townspeople who wished to avoid the saloons.

DANBY MIRROR
EXTRA.

In addition to other attractions at the DANBY

SCHOOL EXHIBITION,

On Friday Eve., March 21, 1873.

The following New, Popular, and Sparkling Dramas will be presented.

SUIT FOR LIBEL.
CHARACTERS.

JUDGE WRIGHT,	Joseph Smith.
COUNSEL FOR PROSECUTION—MR. LOFTY,	James Hogan.
" " DEFENCE—MR. SAPIENT,	William Dodge.
WITNESSES—MR. LOBBEY,	Wm. Emmons.
" MR. O'CONNER,	Ed. Hogan.
" STULY,	H. Schoenfield.
" EMERY,	Charles Smith.
SHERIFF,	Joseph McChesney.
CLERK OF COURT,	L. G. Wagner.
FOREMAN OF JURY,	Jos. Schlick.

"A LITTLE MORE CIDER."

E. APPLEJACK,	Joseph Smith.
Z. APPLEJACK,	David Smith.
D. PEACH BLOSSOM,	Jas. Hogan.
I. PEACHBLOSSOM,	Clem. Dodge.
H. DRINKER,	Jos. McChesney.
MISS MASON,	Miss Mattie Smith.
MISS POLLY,	Miss N. Wagner.

Doors Open at 7 o'clock P. M.

ADMISSION, - - - - - 25 Cents.

The Exhibition will be at the UNION CONGREGATIONAL CHURCH.

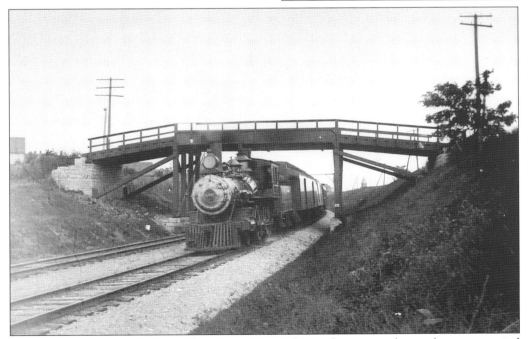

This wooden overpass, built in the 1870s to provide a safe crossing for cattle, once carried Western Avenue traffic over the tracks. It was taken down in 1907 when the engines grew too large to pass under it. This train is approaching from Wheaton.

Harris W. Phillips bought a large estate in 1860 on Park Boulevard, just south of the tracks where the Park Place Condominiums now stand. Phillips at one time owned the meadow where Lake Ellyn would be created, and his son Charles was a major developer. Phillip Ganzhorn later converted this home into a factory for his Korrect Kutter Manufacturing Company.

Erastus "Old Ketch" Ketcham, according to Ada Douglas Harmon, "married his cousin Mary Jane Churchill and lived for more than half a century in the little frame house on St. Charles Road. The old house contains beautiful hand made doors and hand made nails. When he lived there it was a veritable arsenal." Old Ketch's home on the southeast of the Five Corners, where prize-winning gardens flourished in the 1920s, was demolished in 1971 to make room for a currently abandoned filling station.

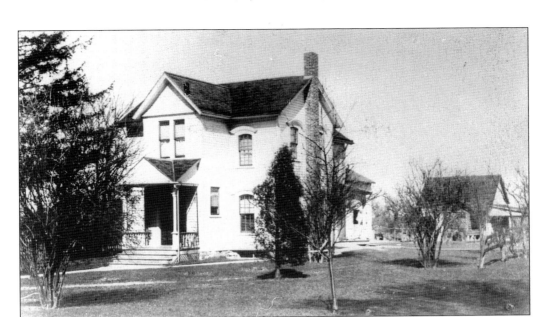

Farmer Jabez S. Dodge was 13 years old, in 1835, when his father William Dodge settled in what would become the southeast part of Glen Ellyn. Jabez journeyed twice to California, by land in 1852 and later via the Panama Canal. In 1873, Jabez built this home on Main Street. Later relocated to Forest Avenue, it was recently demolished for a parking lot. Jabez and Almeda Dodge are pictured below by the well behind the house, which often supplied water for the nearby Duane Street School. Almeda taught school in 1843 in the Babcock's Grove home of Sheldon Peck.

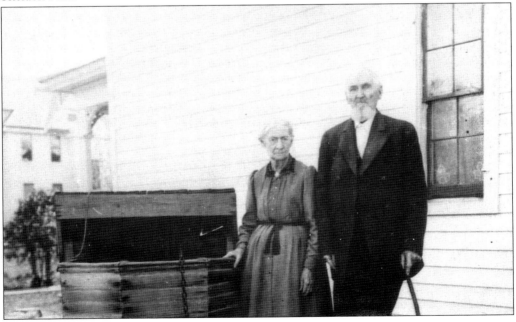

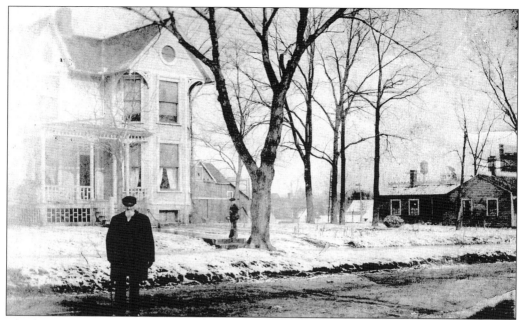

This home was built in 1873 for F. B. Angell, a Rhode Island watchmaker who owned the entire southeast quarter of the block bordered by Main Street, Hillside Avenue, Glenwood Avenue, and Duane Street (see 1874 map on page 36). It was later owned by Orrin D. Dodge, whose father Jabez lived across the street and is seen in this photograph. The home at 424 Main Street was purchased by the village in 1984.

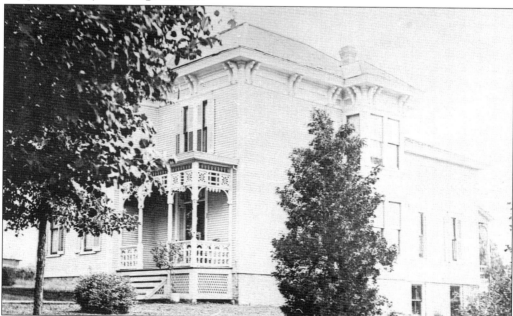

Jabez's son Nelson P. Dodge, a carpenter, built his own home in 1884. One of Glen Ellyn's remaining treasures, it still stands at 549 Main Street. It replaced the home of Dr. Tongue, a little-known early Danby settler whose property can also be seen on the 1874 Prospect Park map.

Erastus Ketcham, John Ackerman, and William Luther were among the founders of the historically abolitionist Free Methodist Church. They built this little chapel in 1886 on the west side of Glenwood Avenue in what is now the McChesney and Miller parking lot. Currently known as the Church of Christ, it has stood on the corner of Elm Street and Prairie Avenue since 1950.

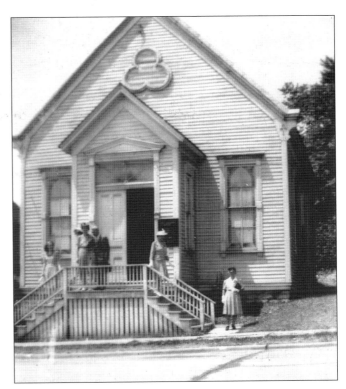

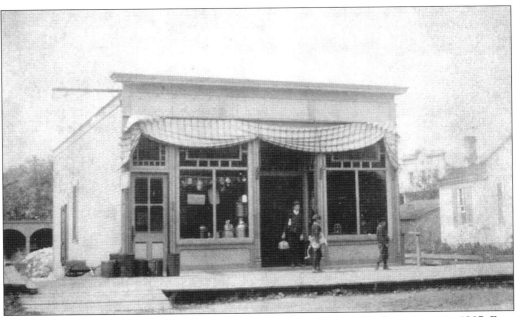

Boyd Brothers supplemented its contracting business by opening a hardware store in 1887. Four years later, it was destroyed, along with most of the other buildings on the west side of Main Street, between Pennsylvania Avenue and Crescent Boulevard, by a fire that spared only the old Cooper store.

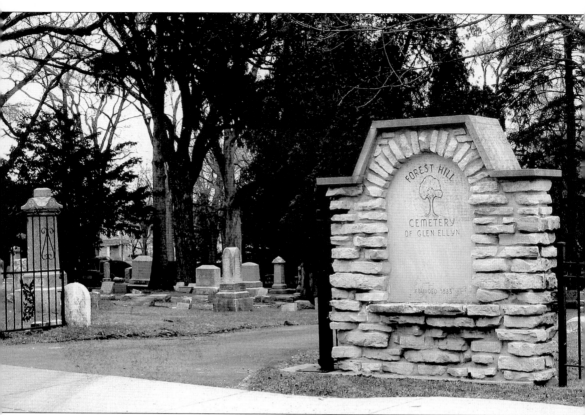

In 1886, Marcellus Jones led a Decoration Day parade of reportedly 1,000 persons and 200 carriages through downtown Prospect Park to the newly christened Forest Hill Cemetery, which grew from the old pioneer graveyard on St. Charles Road. Philo Stacy served as caretaker. His 20-year-old daughter Fannie, "escorted by the members of the Grand Army, made the rounds of the soldiers' graves, covering each with soft mantles of rare and lovely flowers," reported the *Wheaton Illinoian*. "As each mound was reached, Lieut. Stacy announced the name, rank and service of him who rested beneath." Fannie Stacy died four years later, and the inscriptions on the marble stones of the pioneers and many Civil War veterans grow faint with age.

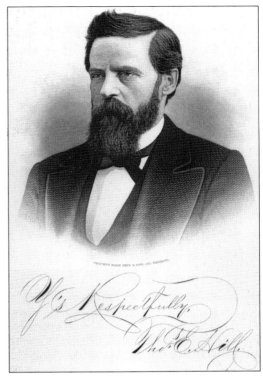

The most influential figure in Glen Ellyn's history, professor Thomas E. Hill settled in Prospect Park in 1885. Best remembered as the author of the very prim Victorian-style book *Hill's Manual of Social and Business Forms*, Hill founded the *Aurora Herald* newspaper in 1866 and served two terms as mayor of that city. Upon his arrival in Prospect Park, he succeeded grocer Joseph R. McChesney as village president. The professor and his wife, Ellen, introduced a new level of society into the still rough-edged farm village and set the tone for its transformation into an affluent suburb.

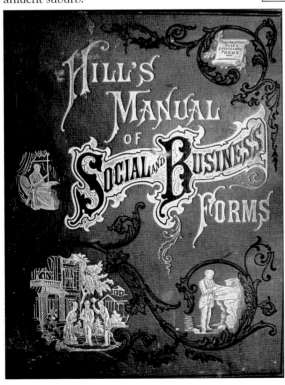

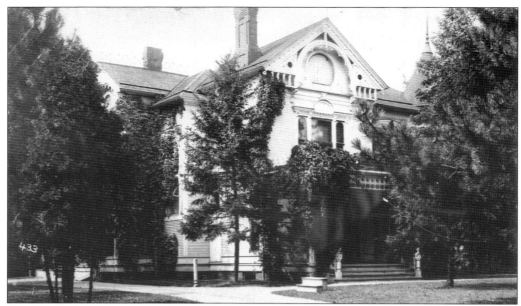

Thomas E. Hill purchased 160 acres of farmland west of Joliet Street (Park Boulevard) and south of Gardner Hill Road (Hill Avenue), on which he developed Wildairs, a beautiful estate overlooking a lake that Hill created by damming one of the area's plentiful spring-fed creeks. Hill developed elaborate plans for Hillmesa, a residential subdivision on his estate, but they were never realized, presumably because he was drawn to the meadow northeast of downtown. Wildairs became the center of local society and the first stop for the affluent prospective buyers of Hill's new properties. His lake was later used to harvest ice, which was stored in insulated sheds and distributed to residents by the Glen Ellyn Ice Company.

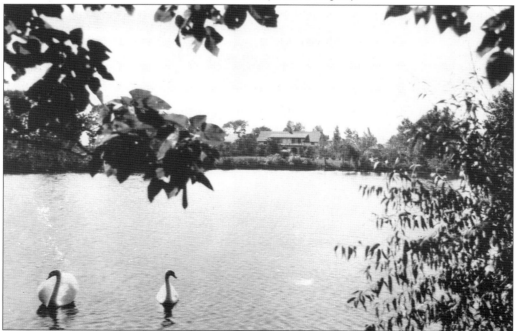

Four

VILLAGE IN A GLEN

The name Glen Ellyn originally referred to the beautiful 50-acre lake that engulfed a meadow where the Rustics had once played baseball. Lake Glen Ellyn, nearly twice the size of the present Lake Ellyn, was the creation of Thomas E. Hill: author, politician, and high-powered real estate speculator. He named it for his wife.

Having built a smaller lake on his Wildairs estate, Hill understood how water could increase the value of the 600 adjoining acres that he had optioned along with Seth Baker. Joined by local investors A. E. Goodridge and Seth Riford, the entrepreneurs subdivided their new Lake Glen Ellyn development under the auspices of the Prospect Park Improvement Association, L. C. Cooper as president, William H. Luther as secretary, and Thomas E. Hill as chairman.

In May 1889, the association announced its plans, and Philo Stacy raised the dam. By the end of June, boats were seen on the rapidly growing lake, and on July 2, the first drowning occurred. That winter they sold ice and welcomed skaters. The next year natural springs just east of the lake were declared to possess healthful mineral properties, and a turreted canopy was built over the source. The newly formed Glen Ellyn Hotel and Springs Company began bottling and selling "the purest water in the world" from the nearby Apollo spring.

In April, the company broke ground for a fabulous 100-room grand hotel on the wooded ridge overlooking the new lake. When droves of buyers responded to advertisements appearing in newspapers and magazines from coast to coast, the *Wheaton Illinoian* suggested that Prospect Park ought to change its name to Glen Ellyn. Prospects appeared bright indeed for the sleepy little village, which officially became Glen Ellyn in July 1891. A disastrous November fire destroyed almost all of the businesses on the west side of Main Street, but energized by the new resort and the great Columbian Exposition in Chicago, downtown Glen Ellyn would soon rise like a phoenix from the ashes.

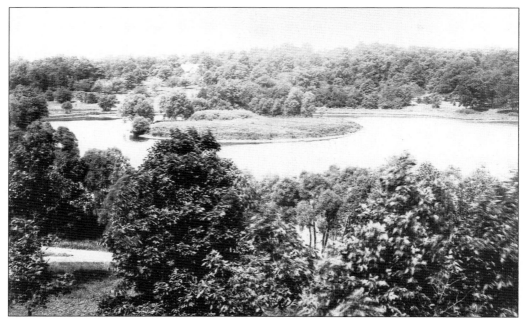

Lake Glen Ellyn was surrounded by old-growth oak forest. This photograph was taken from the tower of the hotel, which overlooked a sheltered bay and Glen Island, now part of the Glenbard West athletic field. The dance pavilion (below), located in the present park, was very popular on summer evenings. However, not everyone was happy about the new lake: "It was level as a billiard table," reported Al Kelley, one of many boys who had played baseball in the now flooded meadow, "the grandest grounds you ever saw. When they put in the lake it was . . . the worst thing that ever happened to Glen Ellyn."

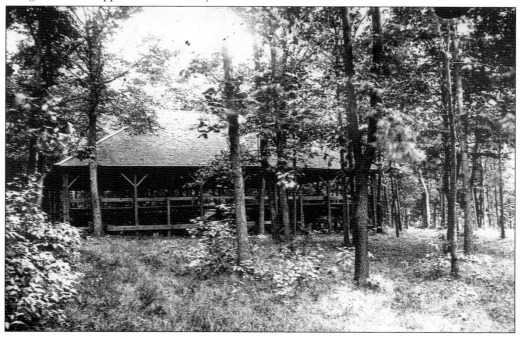

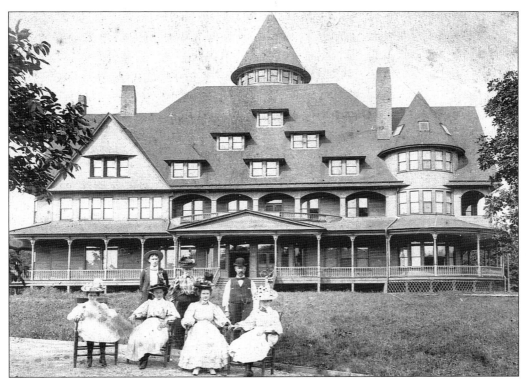

The grand Hotel Glen Ellyn opened in June 1892 with 100 well-appointed rooms. Seth Baker and Seth Riford initially managed the luxurious resort with its lavishly landscaped grounds and lakeside amenities. An 1895 promotional brochure published by the Glen Ellyn Hotel and Springs Company from their offices in Chicago's famous Rookery Building called Glen Ellyn "the Saratoga of the West" with a hotel "of mingled colonial and Elizabethan architecture, beautiful in exterior outlines. The observatory tower commands a sweeping view of all the surrounding country and within its spacious, glass-enclosed walls, a hundred guests can enjoy the pleasure of a panoramic view matchless in beauty."

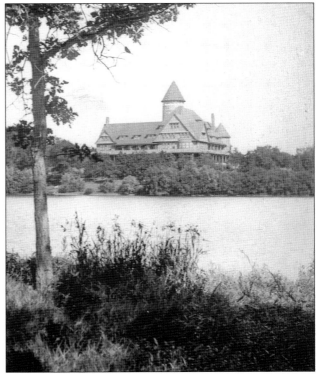

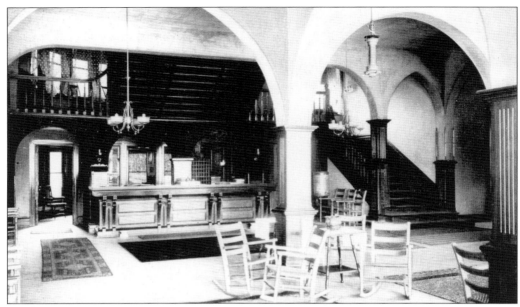

The 1895 brochure described the interior amenities of the hotel, starting with the 100 guest rooms, "all richly trimmed in solid hard woods. The various parlors, reading and music rooms are ample in proportions and are elegantly and richly furnished. The wide corridors and broad stairways are soft to the tread with Axminster [carpeting], while at each landing are orchestral dais and lounging retreats. The great dining-hall, with polished hardwood floors, has accommodations for three hundred guests at one sitting. Guest-rooms and suites are elegantly furnished in solid cherry, satin-finished birch and quartersawed oak. Bath and toilet rooms are on every floor, and also in private suites. The billiard room, dance hall, wine room and tonsorial parlors make the Glen Ellyn first-class in every particular."

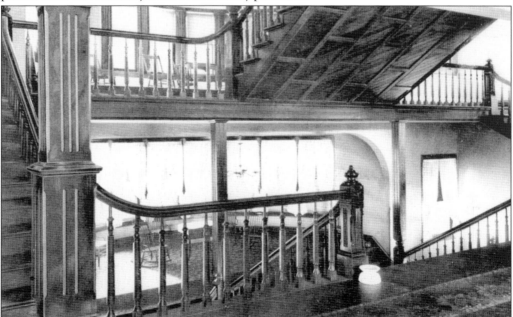

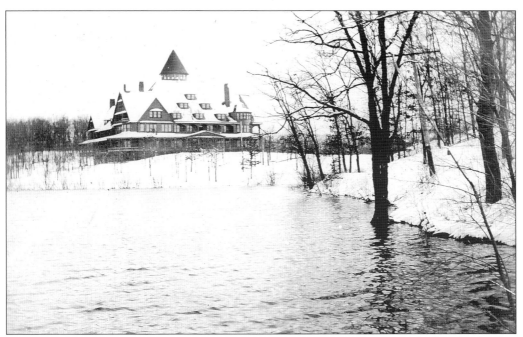

These wintertime snapshots clearly show the location and orientation of the hotel. The first was taken from the point where the brook entered the lake from downtown Glen Ellyn, looking east across what is now the high school athletic field. The sidewalk leading to the park (through the cracks of which the old brook can still be heard today) begins at this place. The bottom photograph shows the view from Crescent Boulevard, looking north over the wooden sidewalk, taken approximately from where Lake Road now intersects with Crescent Boulevard.

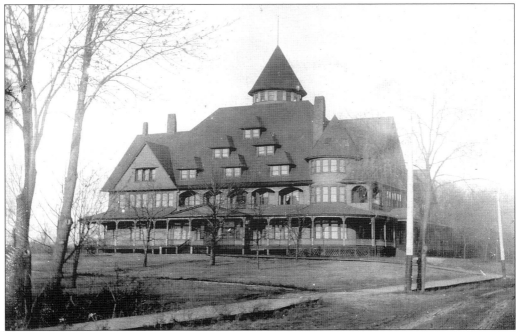

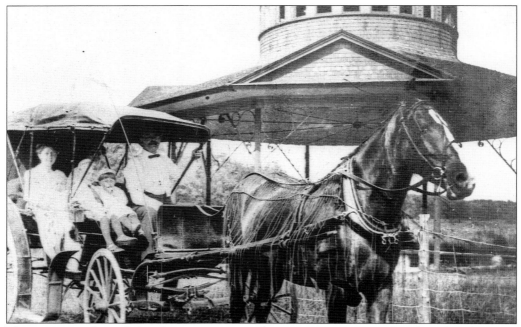

The company claimed that five unique mineral springs were contained within this charming enclosure that echoed the fanciful architecture of the nearby hotel. The Victorian passion for the life-giving effects of mineral water and mud baths ensured investors that the Five Springs would be the centerpiece of the new Glen Ellyn health resort development. The Kimball family are in the surrey.

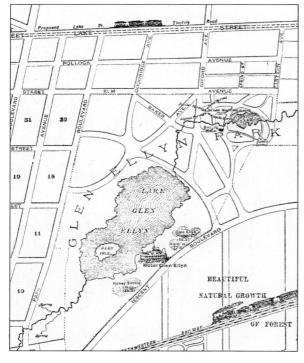

This map, from an 1894 real estate brochure, clearly shows the new lake, hotel, and nearby mineral springs, though the layout of the streets north of the lake bears little resemblance to the finished product. Most interesting is the proposed Lake Street Elevated and Electric Road that was widely expected to run from Chicago on St. Charles and Geneva Roads, still known as Lake Street at the time.

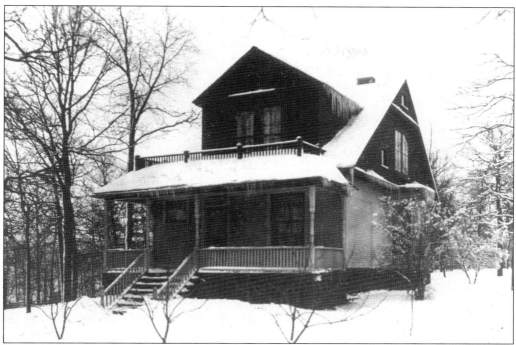

Inastelle Gauch, mother of Glen Ellyn's most celebrated centenarian Ann Bailey Prichard, and her sister Annie were among the company's first customers, as this certificate testifies. Moving to Glen Ellyn from Champaign, Illinois, in 1892, along with their mother, Eliza, they built this home in old Dr. Lewey Quitterfield Newton's apple orchard on a hill overlooking the part of Lake Glen Ellyn that was later filled in. The home still stands at 567 Park Boulevard.

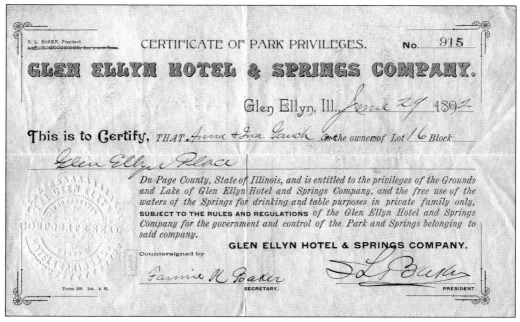

Ada Douglas Harmon also came from Champaign in 1892, and she built her home with this lovely garden right across the street from the Gauchs'. Named after Sen. Stephen A. Douglas, with whom her father had practiced law, Harmon was a celebrated painter and amateur historian who provided Glen Ellyn's first history book, *The Story of an Old Town – Glen Ellyn*, published in 1928.

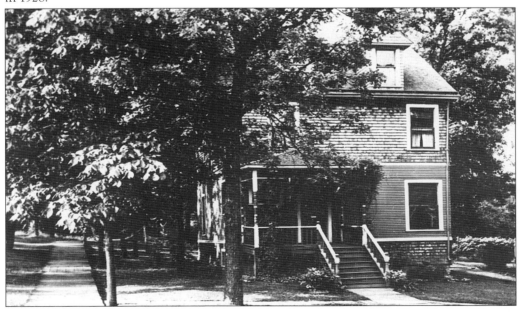

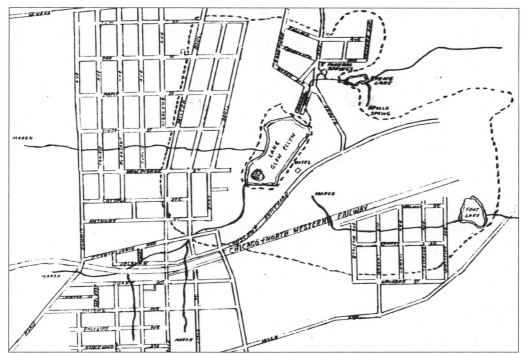

This roughly drawn but accurate map of the newly named village of Glen Ellyn shows Lake Glen Ellyn and the numerous spring-fed brooks that fed into it, including the meandering creek that ran openly through the center of town. The original extent of old-growth forest surrounding the lake basin is shown, some of which survives today in the ancient oaks that grace the parks and wooded residential lots in this area.

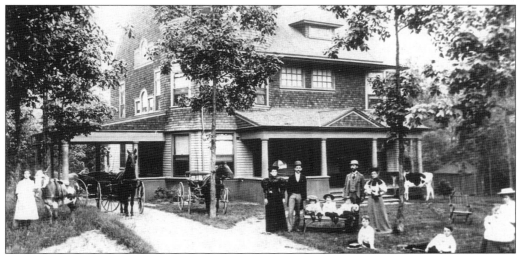

In 1894, A. E. Goodridge turned his spacious home in Philo Stacy's grove into a luxurious clubhouse, with elaborate plans to develop the entire block between Main Street and Forest Avenue into an amateur equestrian and athletic club. The home was purchased instead by Charles Moulton, whose family is seen here along with their horses and cows. Moulton called the estate Eastbourne.

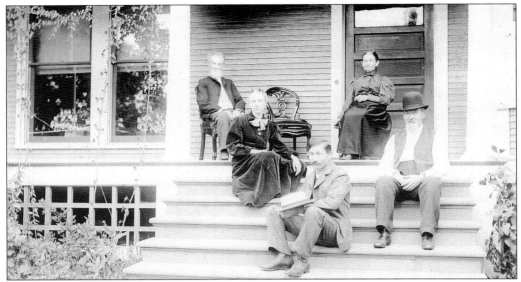

James C. and Mary Gault pose on the porch of their large house that still stands on the southwest corner of Main and Hawthorne Streets, the site of Danby's first one-room schoolhouse. At the time, the home stood alone, surrounded by fields and orchards. James's wife, Mary True Dudley, descended from Thomas Dudley, first governor of the Massachusetts Colony. They had six children, of whom all but ornithologist Benjamin True Gault, center, died young. The elder Gault was a forty-niner and an early railroad man, seen below in a private family-owned coach wearing a long beard and a straw hat. His son Benjamin is left of center in the front row.

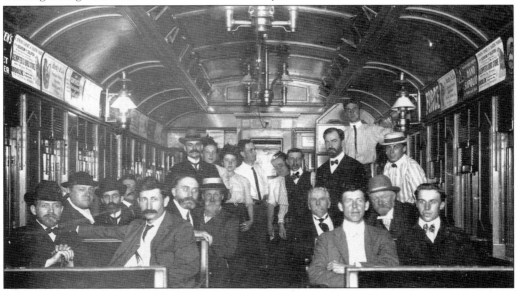

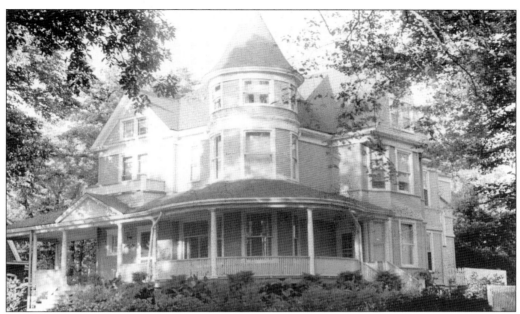

L. C. Cooper paid the princely sum of $4,750 to have this magnificent home built in 1892. Still standing at 545 Park Boulevard, the house Cooper called Birdwood once overlooked Lake Glen Ellyn with a view that rivaled that of the hotel observatory. Today the lake is smaller and the neighboring houses much larger. Less than a month before his death, Cooper wrote about sitting in his library watching the children playing with their sleds outside the window. Those children included his five-year-old granddaughter Ellen Cooper and her best friend Helen Wagoner, who lived across the street at 570 Anthony Street.

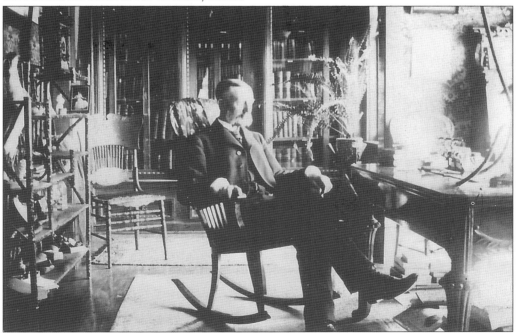

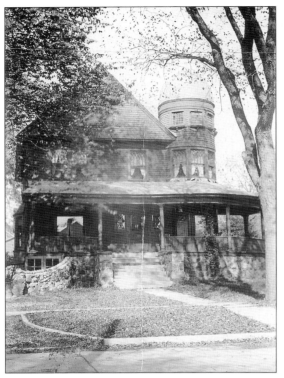

This unique 1893 Queen Anne house at 570 Anthony Street, which cost $5,000 to build, was the last home of Thomas E. Hill and his now blind wife Ellen. Although they lost all of their money, the Hills were able to keep this home because Ellen held the mortgage on the original owner who, like many others, defaulted during the panic of 1893. The professor, pictured in his old age, wrote his later works and died here in 1915. The following year, the home was sold to postmaster Joseph H. Wagoner, whose family lived here until 1964. Helen Wagoner Ward was born in the second-floor turret room in 1918, and her father died here at the age of 85. It was ornithologist Benjamin True Gault's last home and the writer's first.

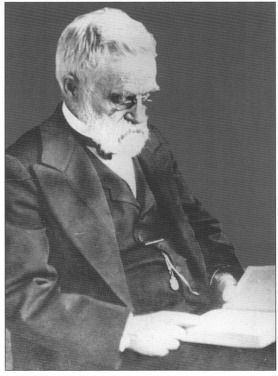

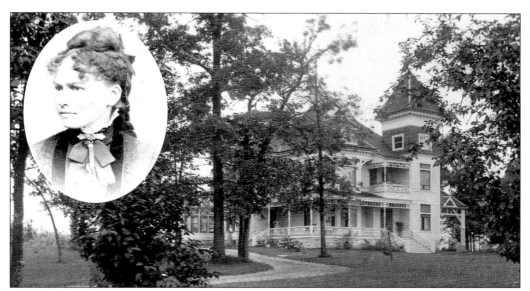

This spectacular Victorian mansion was built in 1893 by Philo Stacy on the site of his father's original 1830s log cabin. Extensively restored and furnished with museum-quality antiques in the 1980s by the Diver family, the home was narrowly rescued from teardown in 1995. Now rotated and relegated to a small corner of the subdivided lot, the home survives, though without its elegant porte cochere. Inset is Carrie Stacy, lady of the house and last surviving member of the family.

Orrin Dodge, son of Jabez, served after Amos Churchill as sixth village president and built this home on the corner of Main Street and Hillside Avenue in 1893. His father's house is seen to the left. Both structures were relocated in the 1920s when this block was built up with the familiar Old English–style buildings that remain there today (see page 109). Orrin's house is now located at 542 Hillside Avenue.

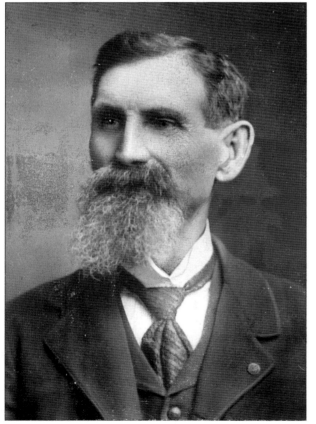

Son of pioneer Seth Churchill, William Henry Churchill served under Marcellus Jones in the Civil War and donated the cannons that were displayed for many years at the corner of Main Street and Crescent Boulevard, now at Lake Ellyn Park. Here he poses proudly with his wife and son in front of his elegant 1897 home at Main and Anthony Streets that was demolished in 1973 to make room for the first of Glen Ellyn's incongruous downtown high-rise developments, the Churchill Condominiums.

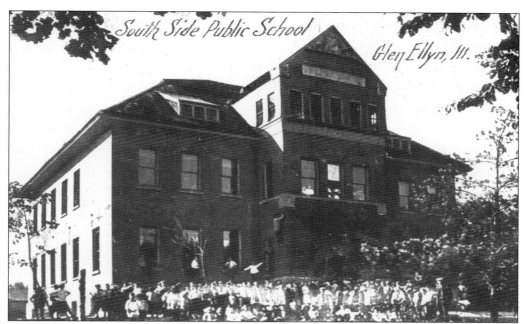

The 1892 building boom continued with the construction of the first masonry school building on the site of Walter Sabin's old frame Duane Street School, which had been relocated to the north side of Crescent Boulevard between Forest Avenue and Park Boulevard. Note the students literally climbing the walls of their new school.

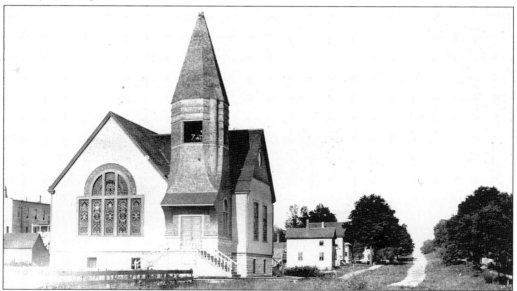

Schoolteacher Georgia Allen donated a lot on the southwest corner of Forest and Pennsylvania Avenues in 1892 for the construction of this new Congregational church, which was torn down and replaced with an office building in 1961. The bell visible in the steeple, originally purchased in 1883 for the old church on Main Street, rings today from the belfry of the present Congregational church, built in 1927. The little path on the right is Pennsylvania Avenue, between Forest Avenue and Main Street.

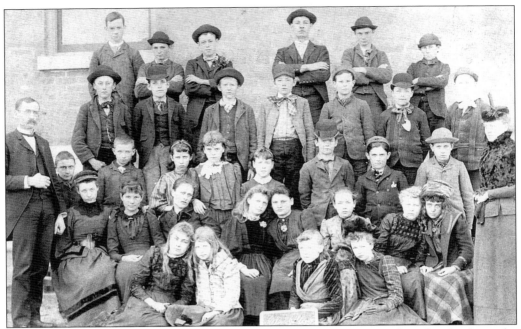

Hats were the order of the day for boys in the early 1890s. Sporting their Sunday best, the students of the newly built Duane Street School are flanked by teachers Luther Grange and Emma Miller.

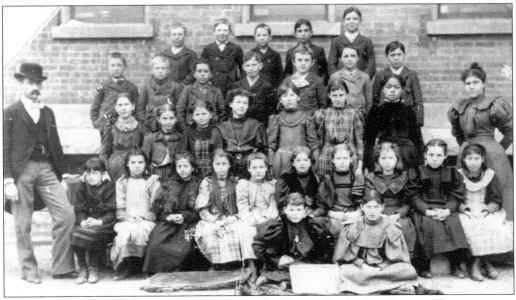

A few years later, the hats are off for the boys and on for teacher Luther Grange. This appears to be the elementary school class, now separated from the high school (see page 65). On the right in the middle row is a girl in dark velvet whose name was curiously omitted from the list on the back of the old photograph. She may be a daughter of Charles and Mary Beaner.

One of the first structures to rise after the 1891 fire that destroyed many of the old Danby-era buildings in downtown Glen Ellyn was this impressive masonry building erected and briefly occupied by the Boyd Brothers, whose 1887 frame store had burned. Here the proud brothers pose along with their customers, including builders, businessmen, well-dressed children, and a lady, quite possibly Mary Beaner. The photograph below more clearly reveals the solid masonry, ornamental ironwork, wooden sidewalks, and the rickety bridge over the creek that still passed openly through town. Radically remodeled in a Venetian style in 1926, this building still stands today.

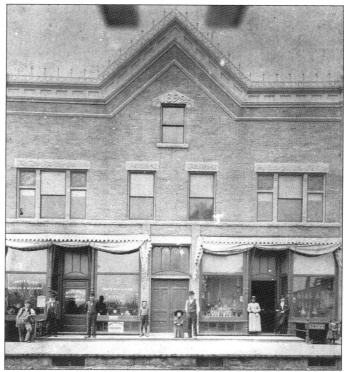

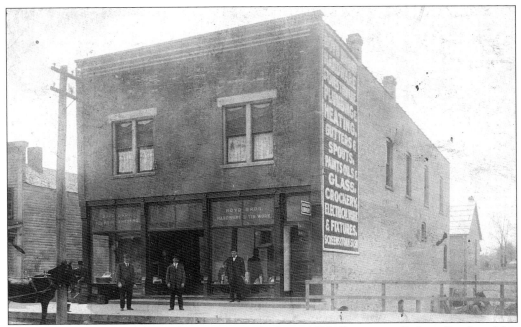

The third and final Boyd Brothers store was built in 1895. Postmaster Robert Boyd and his daughter Pearl are seen below in the combination store and post office. This store soon became Patch Brothers Hardware, where Mildred Patch Mulligan worked until 1964, when the bank decided to replace the solid two-story building with a rather impractical one-story drive-through facility, since converted to offices.

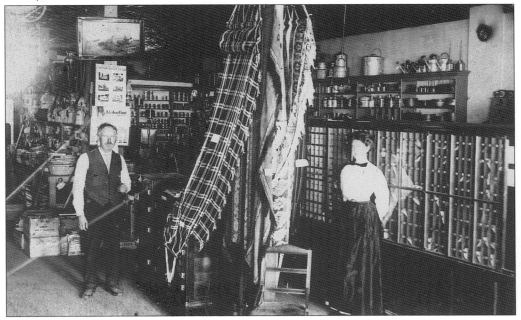

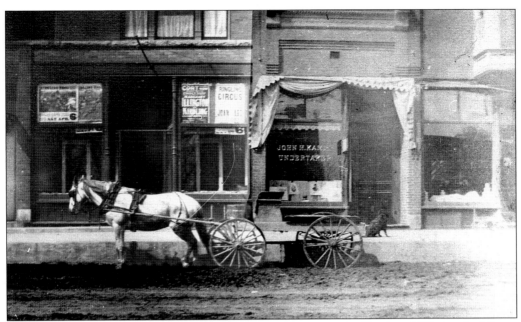

John Kampp's funeral parlor filled the narrow space between the Boyd and Wagner buildings, flanked by a laundry and a bakery. All of these buildings are still standing. (See page 103.)

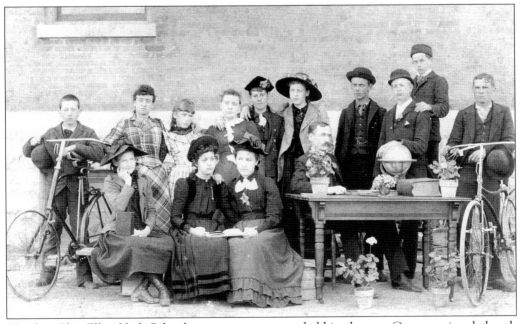

The first Glen Ellyn High School commencement was held in the new Congregational church at Forest and Pennsylvania Avenues on June 15, 1894. Valedictory oration was by Adeline Churchill. After this, the high school course was abandoned, and students attended Wheaton High School until 1916.

The old 1849 Stacy's Corners church building was moved again for the last time in 1892 by Dr. James Saunders, who placed it on a high foundation on Crescent Boulevard, next to the old frame school building that had been moved from Duane Street. Here they both remained until 1962 when they were demolished to make room for the new National Tea Supermarket, which was recently razed to make way for yet another high-rise condominium.

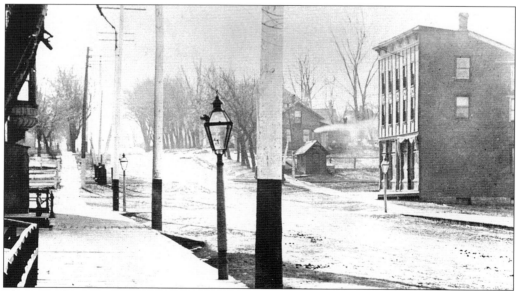

This rare photograph of the historic Danby House was taken shortly before it was torn down in the 1890s. Built in 1852 by Milo Meacham of Stacy's Corners, the building originally stood on the west side of Main Street, just south of the tracks. Later it was moved to the north side of the tracks, and a third story was added. Note the wooden sidewalks, gaslights, and newly installed electrical utility poles.

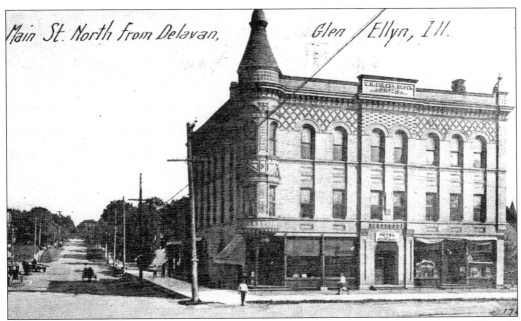

After an 1893 fire destroyed the Mansion House, it was quickly replaced by this delicately ornamented three-story greystone hotel built by J. H. Ehlers. It remained the centerpiece of downtown Glen Ellyn for another 36 years.

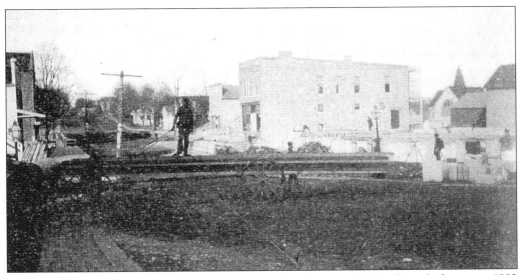

This grainy but informative photograph of Milton Avenue (Main Street) from an 1893 promotional brochure shows Glen Ellyn in transition. On the left is the old 1850s Fleming Grocery and the 1892 Boyd Brothers Building. Across the street is Georgia Allen's home, where the post office now stands, then the McChesney home, the newly relocated 1878 McChesney Brothers Store, and a full view of their brand-new masonry building, behind which can be seen an equally new Congregational church. The ruins of the Mansion House have just been removed, and construction is beginning on the Ehlers Hotel.

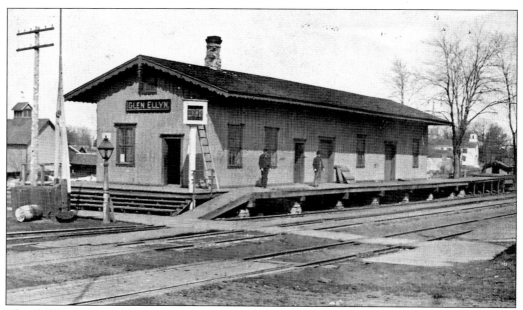

The old Danby station house bore the name Glen Ellyn for just a few years before it was replaced in 1895. The old Duane Street School, relocated to Crescent Boulevard, can be seen on the right in the distance.

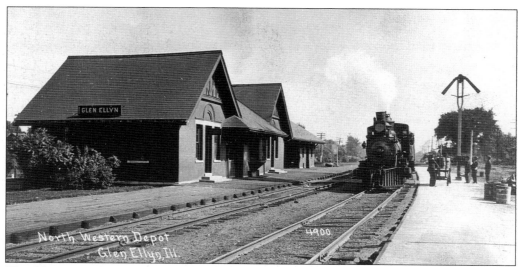

The Chicago and Northwestern Railroad built the first of their many fine suburban masonry station houses some distance to the east of the old depot. Featuring separate men's and women's waiting rooms on either side of the station agent's office (see page 109) with a large circular, marble-topped steam radiator in the center of each, this station stood until the current building replaced it in 1966.

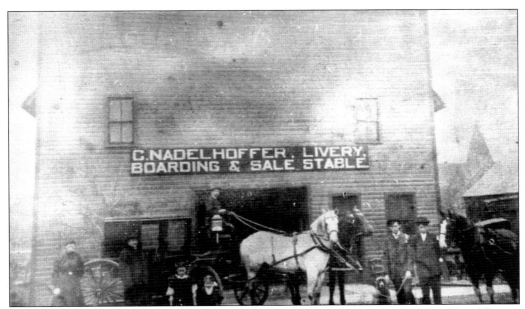

The Nadelhoffer brothers purchased this livery stable on the present site of the Glen Theater from Charles Van Buren in 1898. The Nadelhoffers' horse-drawn bus, according to Ada Douglas Harmon, "was much used by the ladies of the town as a conveyance in those early days. We did not lack for excitement when riding it, for often the driver would be drunk and any minute we might expect to be dumped into a wayside ditch. For many years Black Maria (so called after her namesake in the city which was used to carry prisoners) was to be seen on all important occasions. She served to carry the pall-bearers to the cemetery and the guests to a wedding. She was a comfort and a mainstay on a wet day. In fact she entered intimately into all the affairs of our lives."

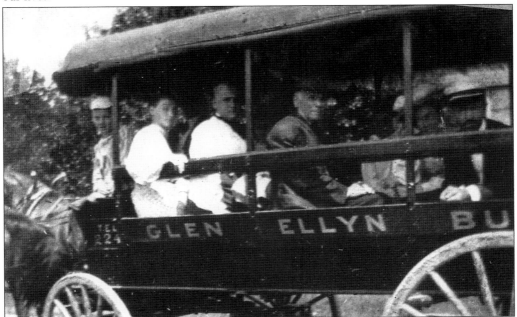

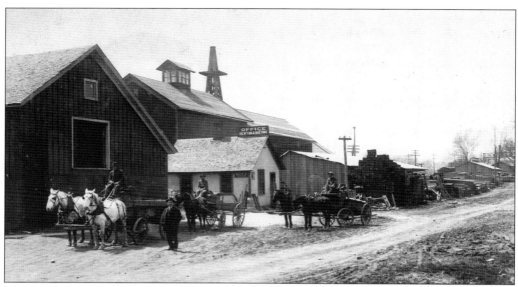

The supply business started by William H. Luther and Amos Churchill in the old station house became Churchill and Newton when Dr. Lewey Quitterfield Newton's grandson LeRoy Q. Newton bought out Luther's interest in 1882. Although this photograph was taken soon after fire chief William H. Baethke came into the business in 1903, it shows the facility very much as it appeared in the late 1890s. Later owned by Alexander Lumber, the warehouse, offices, and yards filled the space between the railroad tracks and Crescent Boulevard from Main Street to Prospect Avenue until 1957. George Cleveland is pictured here driving Newton-Baethke's delivery wagon, which hauled coal and building supplies to village customers.

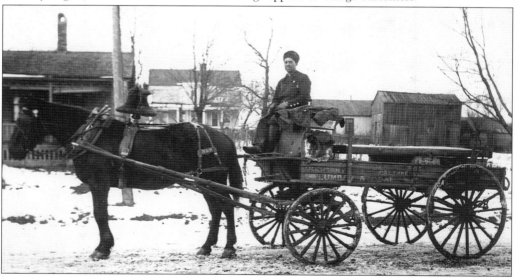

Five

GLEN ELLYN
CONFIDENTIAL

As the 20th century dawned, the nation's love affair with Victorian health resorts was fading. The Hotel Glen Ellyn fell out of the hands of the original company after just a few disappointing seasons, followed by several brief incarnations as a private resort, a health spa operated by the St. Luke's Society, and, most intriguingly, the campus of the radically socialist Ruskin University, which failed when students refused to accept funding from local capitalists.

Prof. Thomas E. Hill lost his shirt, and his beautiful Wildairs estate became a Salvation Army farm for needy children. In 1904, the Apollo Springs bottling plant burned down. Two years later, while undergoing renovations by yet another owner, the grand hotel was struck by lightning and incinerated in two hours time. But the well-heeled Chicago gentlemen who spent their leisure hours here were interested in something other than mud baths and mineral water, and the shiny reputation that the village had worked so hard to achieve began to corrode once again.

Glen Ellyn started to pave its dirt roads, pour concrete sidewalks, and run gas and water piping and electrical and telephone wiring. A new electric rail service carried shoppers and commuters directly onto the Chicago Loop, and automobiles gradually replaced horses as the mode of local transportation. Steel-framed masonry superseded wood in the construction of new civic and commercial buildings. Glen Ellyn and Lombard formed a new high school district to purchase the now weed-choked lake and wooded Honeysuckle Hill where health resort patrons had once picnicked—and where an obscure silent film about the Black Hawk War was filmed in 1912.

As the ranks of the Grand Army of the Republic (GAR) began to thin, a new call to arms rang out, to which Glen Ellyn responded with some 166 active servicemen. Patriotism and temperance reinvigorated the villagers, and by the end of the First World War, Glen Ellyn's tarnished reputation was on the mend. And with hundreds of new homes and scores of commuters now riding the rails to Chicago every day, Glen Ellyn was ready to establish itself as a leading suburban bedroom community.

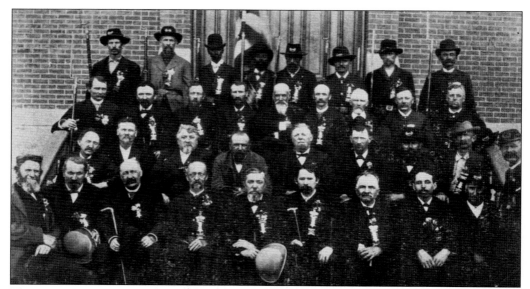

The aging GAR veterans of DuPage County gathered for this portrait at the beginning of the 20th century. Philo Stacy is at the lower left, and Amos Churchill is third from the left in the third row, followed by Levi Casselman of Lombard, Capt. Marcellus E. Jones, and William H. Luther. Bearing arms on the left in the fourth row are pioneer brothers Alonzo and Miles Ackerman. Former slave Charles Beaner is fourth, bearing the colors, and his neighbor William Henry Myers is fifth.

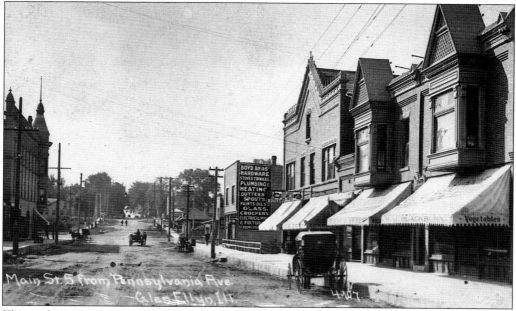

This early-1900s photograph shows the G. M. H. Wagner Grocery building that was built after the 1891 fire and still stands today, as well as both of the Boyd Brothers' masonry buildings. Beyond stands the old frame Fleming Grocery store that had been occupied by the Coopers during the Civil War and the McChesneys during the 1870s. Note the new carriage-high concrete sidewalks.

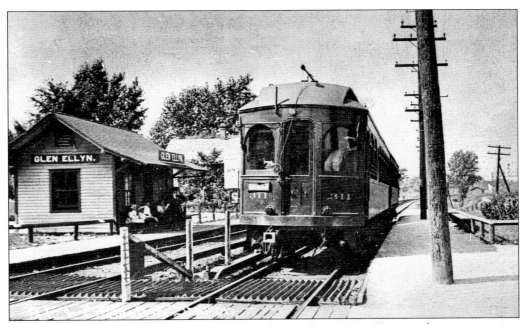

The Aurora, Elgin and Chicago electric railroad opened in 1901, offering a direct connection to the Metropolitan West Side Railroad and the downtown elevated loop. The original wooden depot on the south side of the tracks, west of Main Street, was eventually moved to the Taylor Avenue stop.

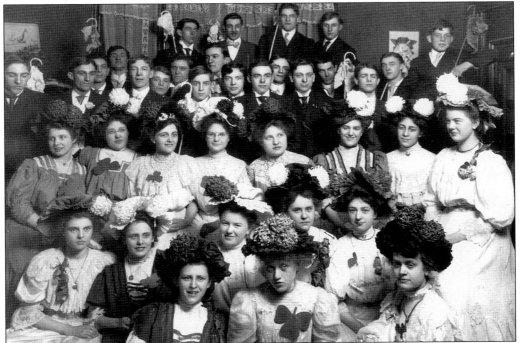

This group of young villagers who gathered for a St. Patrick's Day celebration in 1901 includes second- and third-generation Coopers, Boyds, Churchills, McChesneys, and others.

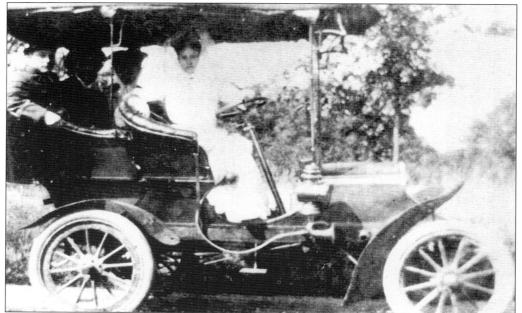

S. T. Jacobs brought this red Franklin automobile, the first in the village, to town in 1903. His daughter Gretchen, who later married Charles McChesney, was the first Glen Ellyn woman to drive a car. The Franklin was built in the same part of New York from which the Babcocks, Churchills, and Dodges had come 70 years earlier.

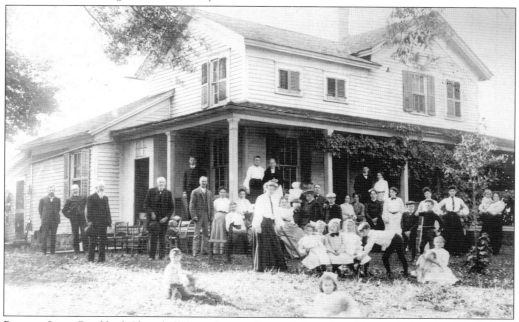

Pioneer Isaac Bradford Churchill (standing in front of chairs) and his wife Angeline (on porch in black) celebrated their 63rd wedding anniversary at home with their family in 1904. Isaac built this farmhouse on Swift Road in 1846 on land that he had claimed when he arrived with his father, Deacon Churchill, in 1835. His descendants live there today.

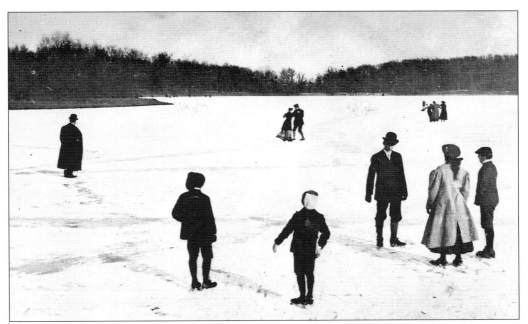

Lake Glen Ellyn offered year-round fun for the villagers, including these fashionably attired skaters in the winter of 1905 and swimmers in 1906. Skating remains popular on Lake Ellyn a full century later.

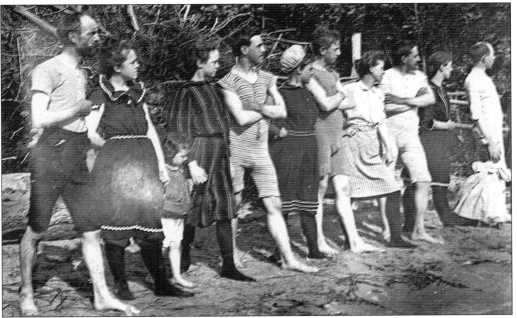

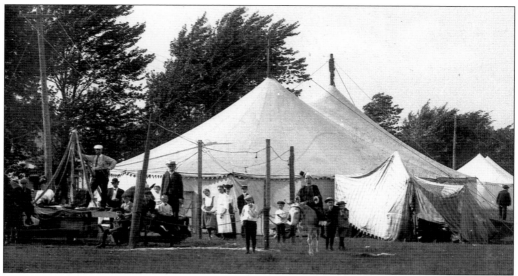

Isaac Bradford Churchill's great-grandson Clarence Curtis recalled the 1905 Glen Ellyn Country Fair: "The first one was held on a vacant lot just north from the present Congregational Church, which was owned by Grandpa Amos Churchill. Dad got the idea of making a Merry-go-round. He got an axle and one wheel and on this fastened two 2x12's about 16 or 18 ft. long. One end of the axle was put into the ground so that it stood upright, then the wheel was put on and board seats were nailed on the ends of the 2x12's. A mule was borrowed from Uncle Joe Clarke to pull the Merry-go-round around. It made quite a hit. The next year another set of cross-timbers were added, giving four seats."

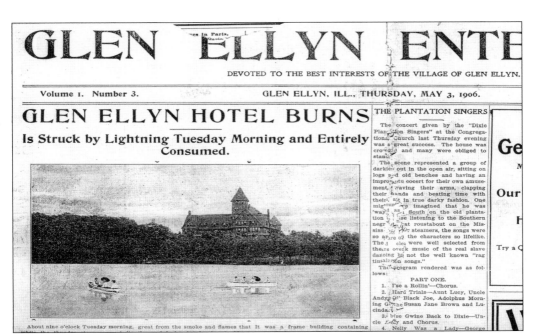

GLEN ELLYN ENTE

DEVOTED TO THE BEST INTERESTS OF THE VILLAGE OF GLEN ELLYN.

Volume I. Number 3. GLEN ELLYN, ILL., THURSDAY, MAY 3, 1906.

GLEN ELLYN HOTEL BURNS

Is Struck by Lightning Tuesday Morning and Entirely Consumed.

About nine o'clock Tuesday morning, great from the smoke and flames that It was a frame building containing

THE PLANTATION SINGERS

The concert given by the "Dixie Plantation Singers" at the Congregational Church last Thursday evening was a great success. The house was crowded and many were obliged to stand.

The scene represented a group of darkies out in the open air, sitting on logs and old benches and having an impromptu concert for their own amusement, waving their arms, clapping their hands and beating time with their feet in true darky fashion. One might have imagined that he was away down South on the old plantation or else listening to the Southern negro at his ront roustabout on the Mississippi river steamers, the songs were so natural or the characters so lifelike. The dies were well selected from theirs overk music of the real slave dancing but not the well known "rag timsale um songs."

The program rendered was as follows:

PART ONE.
1. I'se a Rollin'—Chorus.
2. Hard Trials—Aunt Lucy, Uncle Andy, Ol' Black Joe, Adolphus Morning Of the Susan Jane Brown and Lucinda.
3. I'se Gwine Back to Dixie—Uncle Eddy and Chorus.
4. Nelly Was a Lady—George

This issue of the short-lived *Glen Ellyn Enterprise* newspaper tells the sad story of the early morning fire that destroyed the Hotel Glen Ellyn on May 1, 1906, five days before the San Francisco earthquake. It also features a glowing review of an amateur minstrel show, whose costumes in this 1904 photograph reflect how little real social progress had been achieved in the half century following the Civil War, enjoyed by the members of the Congregational church.

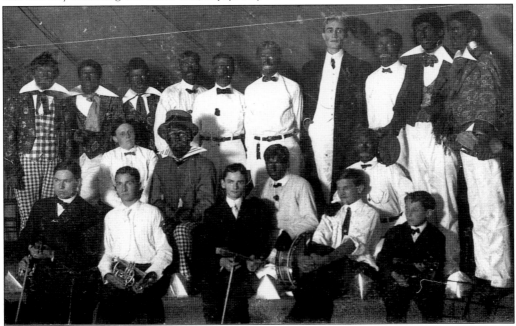

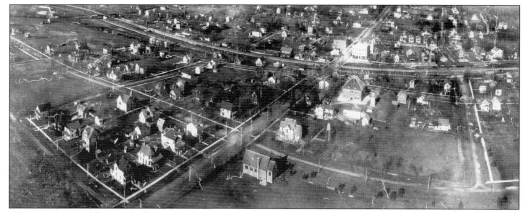

This century-old aerial photograph was taken "by flying about six large kites and then feeding the camera up the cable," according to Clarence Curtis. "They tripped the shutter by cranking a generator which sent a current up to the camera. Sometimes they would let some of the boys go up on the cable instead of the camera." Note that houses are just beginning to appear in the treeless fields south of Hillside Avenue, although they had been subdivided for more than 30 years, and no commercial buildings yet exist south of the tracks. In the center foreground is St. Mark's Mission Church (see page 88), the homes of Orrin and Jabez Dodge (see page 59) and the old Duane Street School (see page 61).

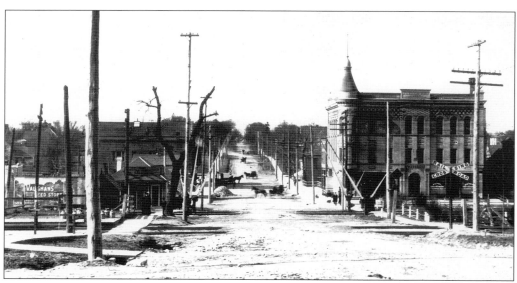

At ground level, Main Street presented a rather bleak picture around 1905 when this photograph was taken from Duane Street looking north (see page 21). The horses do not seem to know which direction to pull their wagons in the dirt road, while a lady in black follows the wooden sidewalk toward John LeMessurier's real estate office on the site of the old Danby House.

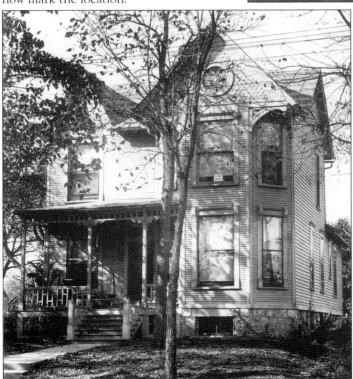

Among the many Civil War veterans who rest in Forest Hill Cemetery is the author's great-grandfather William A. Wagoner, pictured here with his granddaughter Ruth in the garden behind his home at 424 Main Street. Wagoner had just turned 18 when he fought in the Battle of Shiloh and then followed Gen. William Tecumseh Sherman to Savannah. Formerly postmaster of Sabetha, Kansas, Wagoner worked as a ticket agent on the Metropolitan West Side Railway, commuting to Chicago daily on the Aurora, Elgin and Chicago. He bought this house in 1906 from Orrin Dodge. A village parking lot and "Garden Clock" now mark the location.

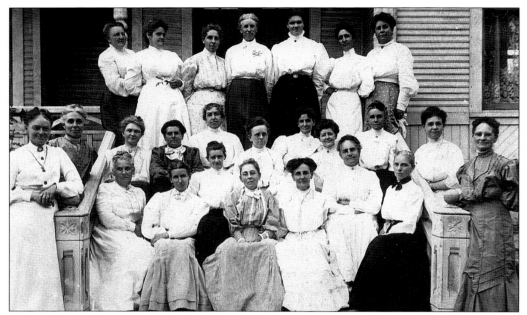

They did not yet have the vote, but women were the heart and the backbone of Glen Ellyn society, providing for the needs of the less fortunate long before the government stepped in. The Utili Dulci Society, a benevolent women's club formed during the recession of 1873, held this reunion in 1905. Founding members included Philo Stacy's daughter Carrie, standing at left, and schoolteacher Georgia Allen at right.

A woman of singular strength was Hannah Dissette Wagoner, seen here on the front porch of her 424 Main Street home. Daughter of an Irish Catholic immigrant who sailed to Canada in 1826 and converted to Methodism, young Hannah had cared for escaped slaves who came to rural Ontario on the Underground Railroad. She married a Union soldier, and two of her brothers crossed the border to join the Union Army.

Originally built to generate electricity for the village and to pump water up into the nearby elevated tank, the Power House, which stood behind the old village hall, was converted in 1906 to produce gas from coal—a technology that is now gaining popularity as a clean-burning alternative fuel. Gas lighting remained popular in homes in the days when electric lamps were expensive and short-lived.

The eighth-grade class of 1907 is seen in front of the old Duane Street School with teachers Edna Osborne (left) and Sarah Craw. The girls from left to right are Ruth Gordon (LePage), born here in 1893 and a major source of historical information until her death in 1993; Florence Robey (Kroeger), who served as principal of Benjamin Franklin School for 29 years; Zoe Moulton; and Louise Patch. The little boy on the right is William Wagoner's youngest son, Willie.

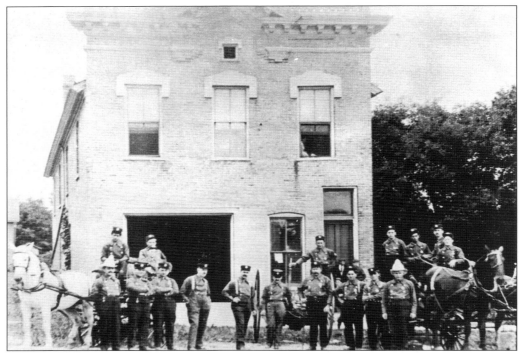

Inspired by the catastrophic loss of the hotel, Glen Ellyn raised a volunteer fire department and moved into the old village hall that still stands today on Pennsylvania Avenue. The white horse, a veteran of the Chicago Fire Department, pulled a delivery truck between fires. When the bell rang, he would bolt for the firehouse (often leaving his driver stranded) where they would hitch him up to this ladder wagon. Included in this group are Robert Boyd, Charles McChesney, William Baethke, William Nadelhoffer, and no less than four Wagners.

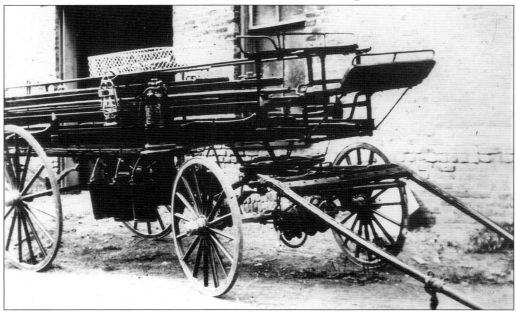

As they still do to this day, the whole village turned out for parades. The 1906 Independence Day parade featured a little brass band followed by Black Maria and a string of coaches. In the photograph below, village children gather on the high new concrete sidewalk during the 1909 Labor Day parade. Concrete sidewalks replaced wood in 1906, but Main Street remained unpaved for another decade.

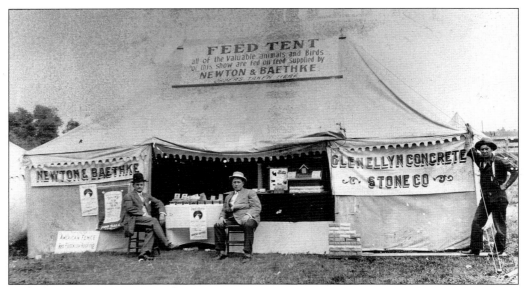

The Churchill and Newton grain and lumber business became Newton-Baethke when William H. Baethke (left), later to become fire chief, went into a partnership with LeRoy Q. Newton (right, seated). Here they took advantage of the country fair to promote their businesses.

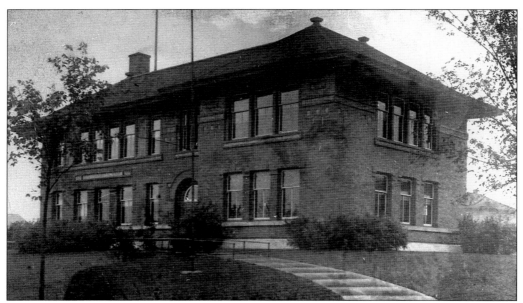

Hawthorne School, the second in the Glen Ellyn School District, was built in 1909 on the southwest corner of Pleasant Avenue and Hawthorne Street. A new school in the middle of the block, the author's alma mater, was built in 1925. The first building was torn down in the 1930s and the second in 1995, replaced by homes.

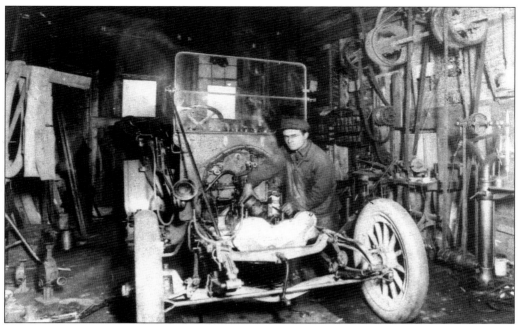

As electric refrigerators replaced iceboxes and automobiles replaced horses, the Miller brothers adapted by converting their icehouse into Glen Ellyn's first automobile repair shop. There were only four cars in Glen Ellyn in 1910, but they broke down constantly. Miller's well-used little service car carried tools to get stalled cars going—assuming the owners could find a telephone with which to call 10 for help.

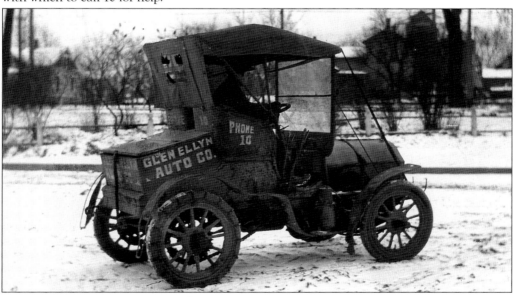

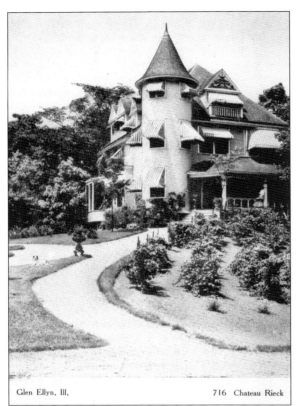

Glen Ellyn, Ill, 716 Chateau Rieck

In the 1890s, Charles and Emily Rieck operated a very successful service for Chicago businessmen in the Arena Hotel on Michigan Avenue, not far from Marshall Field's store. They purchased Dr. Samuel A. Lundgren's dark, somber-looking Victorian mansion on Crescent Boulevard, at Riford Road, and gave it an extreme makeover, complete with brightly colored awnings (as seen in this souvenir postcard), and they built a large guesthouse for the use of the young ladies who worked for Madam Rieck. The nearby Taylor Avenue train depot served as a discrete way-station for gentlemen callers from Chicago. In 1910, Mayor Carter Henry Harrison Jr. closed down all the brothels in Chicago, and the following year the local Women's Christian Temperance Union (WCTU) closed down the "saloons" in Glen Ellyn, including Madam Rieck's. According to Pam Conrad, when the ladies lost their jobs, Marshall Field generously provided less compromising positions for them in his store.

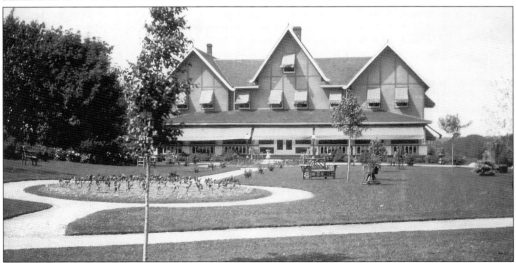

Platinum blonde Emily Rieck drew the stares of local boys, the ire of reformers, and the quiet gratitude of more than a few residents. Shown here in the garden of her lavishly landscaped estate, Madam Rieck inspired a love-hate relationship with Glen Ellyn. Pam Conrad suggests that some overburdened Victorian women may have quietly relied on such services as a form of birth control. Ida Brietzke, Rieck's employee and later her friend and caretaker, became pregnant on the job by German journalist Charles Hundt. They were married before Brietzke gave birth to Pam Conrad's grandmother.

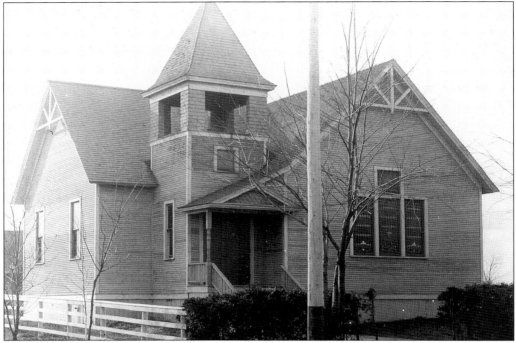

The Methodist Episcopal Church (above) and St. Mark's Mission Church were both built in 1901 on Hillside Avenue near Main Street on land donated by developer Charles Phillips, whose generosity was reportedly inspired by the pledge of church members to keep his patronage of Chateau Rieck out of the newspapers. St. Mark's, built by Boyd Brothers, changed its name to St. Mark's Episcopal Church and was replaced by a new building on the same site in 1950. Unfortunately the quaint old Methodist church was recently torn down for a parking lot.

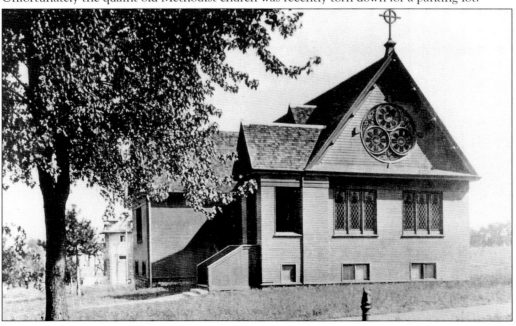

The property of the fallen Glen Ellyn Hotel and Springs Company was subdivided and sold off, as shown in this plat. Eventually Forest Avenue extended to Hawthorne Street, and lots 57 through 68 became Lake Ellyn Park. Lots 5 through 9 are the original Glenbard High School campus, 2 and 3 are now the school parking lot, lot 10 became an extension of Lake Road in 1956, and the former lake and island south of lot 58 is now the athletic field.

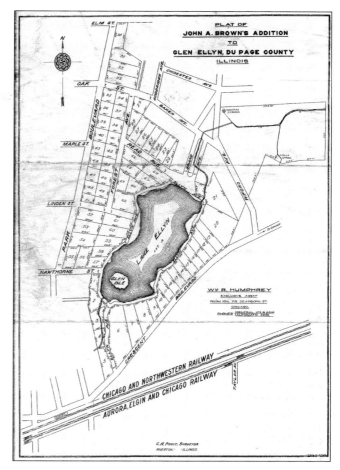

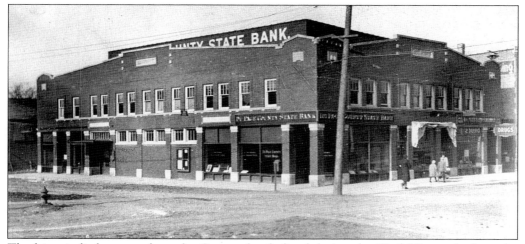

The historic little store where the Cooper family lived during the Civil War, and where the McChesney grocery store had been located during the 1870s (see page 33), was replaced in 1911 by the DuPage County State Bank building, still standing today though barely recognizable.

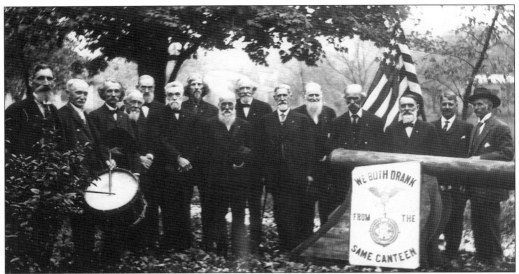

A total of 62 Civil War veterans are buried in Forest Hill Cemetery, most of whom participated in the meetings and reunions of the Grand Army of the Republic. Philo Stacy hosted many meetings in the grove across from his home. This reunion of old soldiers took place there around 1913. On left is William H. Churchill, fourth from left is Amos Churchill, fifth from left is William Fleming, seventh from left is Alonzo Ackerman, eighth from left is Joe Wagner, 11th from left is Philo Stacy, and on the far right is William H. Luther.

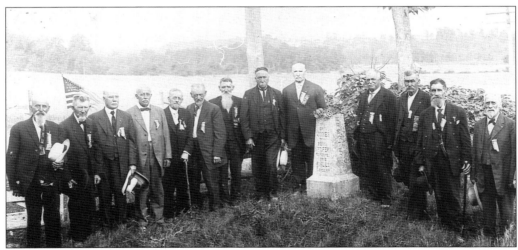

William H. Churchill traveled to Gettysburg in 1913 with fellow veterans of the 8th Illinois Cavalry to mark the 50th anniversary of the great battle of the Civil War. He appears in this photograph, second from right, standing beside Levi S. Shafer on the far right. It was with Shafer's rifle that Marcellus Jones, who died in 1900, had fired the opening shot of the battle. The monument marking the location of that shot was erected in 1886 and can still be seen on the Chambersville Pike.

Otto and Herman Miller replaced their old icehouse repair shop next door to Nadelhoffer's Livery in 1913 with this sturdy steel framed brick structure, shown here under construction, that stands today on Crescent Boulevard. Remodeled in the 1920s with a second floor, it was long known as Kar-Lee's flower shop and now hosts Starbucks and Pacific Blue.

The old horse and buggy remained popular during this era, as seen in this 1913 photograph of the Skillins family in their proverbial surrey with the fringe on top in front of the Kendall home at 490 Phillips Avenue.

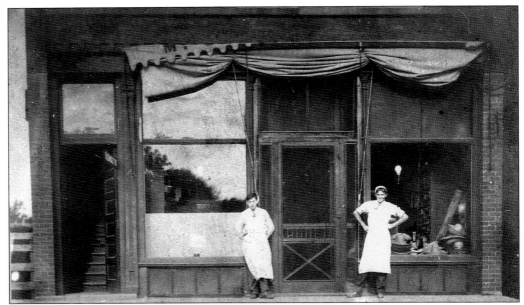

McChesney Foods was the oldest of several grocery stores in downtown Glen Ellyn in the early 1900s. The fourth location of the store, founded in 1862 by Joseph R. McChesney, was located on Main Street, just north of the Ehlers Building. Behind the counter on the left inside is Charles McChesney.

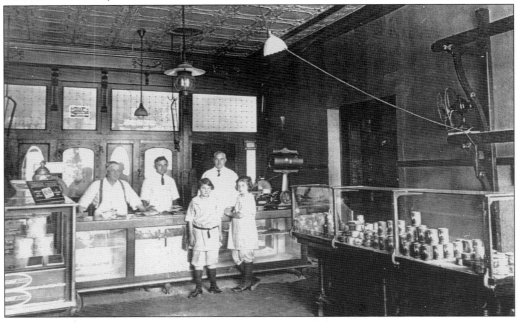

Arthur H. Neahr, whose store was just north of McChesney's, offered straw hats and sun bonnets for 18¢ in a 1912 issue of the *Glen Ellyan*. A founding member of the Boosters Club, Neahr promised "to boost Glen Ellyn, muzzle the dogs, grade the streets, cut the weeds and collar the men. I have the collars."

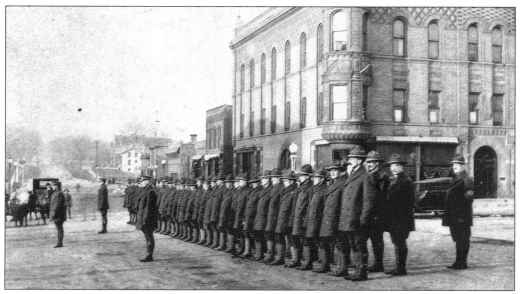

The men of the Home Guard assemble for inspection on Crescent Boulevard in front of the Ehlers Hotel in 1914. Their services would soon be needed elsewhere.

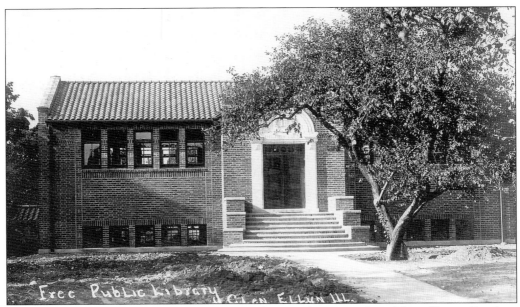

The Glen Ellyn Library was started in 1881 with 100 volumes purchased from Harper Brothers for $100. The collection initially resided in a bookcase at the Congregational church. Georgia Allen was the first librarian. In 1911, the Library Association solicited a grant from Andrew Carnegie, and the Glen Ellyn Public Library opened in this brick building in 1914. It still stands hidden inside the High School District 87 offices at Crescent and Park Boulevards.

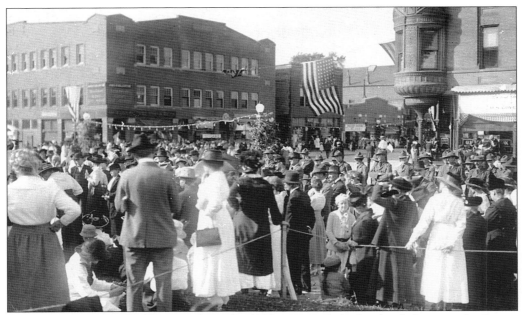

Although an attempt had been made in the 1890s to provide high school classes at the Duane Street School, the High School District was not formed until 1915. A third floor was added to the new DuPage County State Bank building, seen here during the 1918 bond rally, for students who had been attending classes at Wheaton High School.

The eldest son of William and Hannah Wagoner, Joseph Hill Wagoner ran a trading post on the border in Pecos, Texas, during the Mexican Revolution and was appointed postmaster of Glen Ellyn in 1916 by Woodrow Wilson. A lifelong Democrat, Wagoner had to run as an Independent to get elected as Milton Township tax assessor in 1942, a job he held until he was 83. A regular in village parades, Wagoner is seen in the bottom photograph at left with fellow Spanish-American War veterans Fred Surkamer (center) and Herman Hitt.

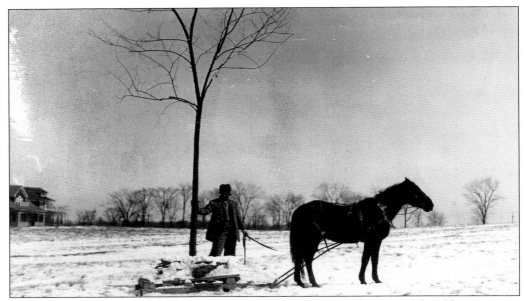

Outside of the old grove on the northeast side, Glen Ellyn was not originally the wooded suburb that is known today. A local physician named Frank Johnson planted many of the trees that shade residential streets laid out a century ago in farmers' fields. Appointed as village forester in 1916, "Doc" Johnson worked hard to cultivate hybrid red maples, planting hundreds on the parkways of treeless new subdivisions and setting out many varieties of ornamental and shade trees in village parks. He is seen here supervising the installation of a sidewalk that encroached upon mature trees.

Massive rallies were held across the country during the Liberty Loan drive to promote the sale of war bonds, including one at the intersection of Main Street and Crescent Boulevard in 1917. The overhead shot was taken from the roof of the new bank/high school building, showing the raised platform by William H. Churchill's cannons in the little memorial park. The horse trough in front of the platform, donated to the village by William C. Newton in 1907, remains, but the park is now a parking lot.

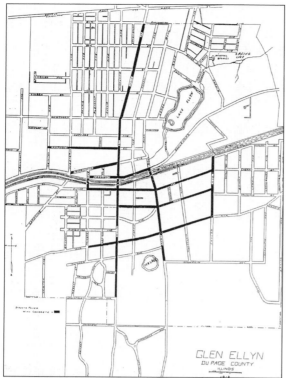

This 1918 map shows the rapid growth of south side subdivisions during the first two decades of the 20th century and the extent of the newly paved streets (in black). Thomas E. Hill's former 160-acre Wildairs estate with its "Ice Lake" remains essentially intact.

The Congregational church moved into this beautiful new brick building on Anthony Street in 1919, the first of several wings on the property. The Grace Lutheran Church moved into the 1892 frame building at Forest and Pennsylvania Avenues.

The class of 1918 was the first to complete two full years at the new Glen Ellyn High School above the bank. Later that year, four of the graduates joined 16 other women in their Congregational church Bible study group to form the M.M.M.'s, a social service club that kept the meaning of its name (Many Marys and Marthas) a secret for almost 80 years. Three of those 1918 graduates and charter members of the M.M.M.'s—Ann Bailey Prichard, Mildred Patch Mulligan, and Helen Myers Clippinger—maintained a close friendship from their childhood throughout their extraordinarily long lives. All were born at the end of the 19th century and lived to see the 21st. In 2001, they were interviewed at length by actress Julia Roberts for an as yet unreleased television documentary celebrating this long friendship.

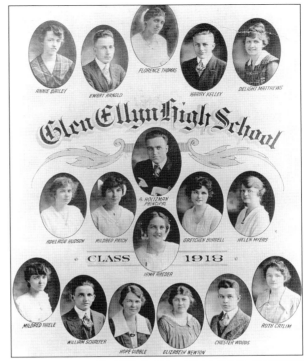

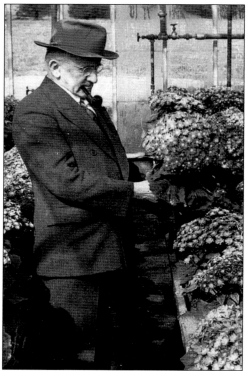

After serving in the Spanish-American War, Ohio native George Jacob Ball came to Glen Ellyn to grow sweet peas for the cut flower market. In 1910, he built a greenhouse at the west end of Hawthorne Street, and by 1918, Ball Seed Company was producing flower seeds for the trade. A family-owned business now headed by his granddaughter Anna Caroline Ball of Glen Ellyn, Ball Horticultural Company has operations on six continents.

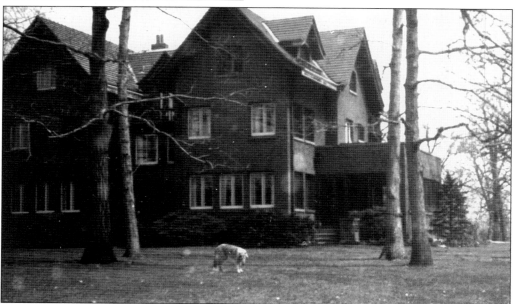

Warwood, the country estate of contractor Walter A. Rogers located just north of the Morton Arboretum, is now known as the Glen Ellyn Woods and Valley View subdivisions. His 1914 mansion still stands. Bates and Rogers built tunnels, canals, power plants, and bridges from New York City to Oakland Bay and Alaska. A prankster who once put a fake fly in Helen Ward's coffee, Walter Rogers is memorialized in the Rogers Chapel at the Congregational church.

Six

BOOM, BUST, AND BEYOND

Glen Ellyn experienced another burst of growth in the 1920s. Newfound wealth produced magnificent brick institutional structures including Glenbard High School, the Congregational church, and the junior high school. Stately homes were tastefully set back on spacious lots. The new Planning Commission's admirable architectural guidelines are still reflected in the Old English half-timbered commercial buildings like the Glen Theater on Crescent Boulevard and the Acacia Building on south Main Street.

In her 1928 history, Ada Douglas Harmon optimistically noted that "North Avenue, the first forty foot highway through the county coming nearby this summer, may waken this district into booming subdivision activity." What Harmon did not know was that just nine months after her book went to press, the whole nation would go bust.

Villagers tightened their belts in the 1930s as construction, growth, and commerce came to a grinding halt. Although the New Deal public works programs provided some badly needed jobs, most struggled to find work until the economy shifted back into high gear for another World War. Men and women who did not go into uniform went to work for the war effort. Scrap drives, war bonds, gas rationing, and victory gardens all contributed to the Allied campaigns as once again villagers waited anxiously for news of more than 1,300 loved ones who went to war. Eighty-one did not return.

The "greatest generation" enjoyed a hard-earned reward of postwar prosperity characterized by forward-looking optimism and inconspicuous affluence. Extravagance was simply unfashionable. Economically more diverse in the 1950s than today, Glen Ellyn's best neighborhoods featured moderate-sized, unpretentious homes alongside mansions and architectural gems, with the children of bank presidents, plumbers, and postmen all playing in the same backyard.

Subdivisions spread north and south, and three more Glenbards were built. The lofty architectural goals of past village planners were forgotten as historic buildings and open spaces yielded to a stylistic potpourri of commercial development. While Glen Ellyn has since recognized and retained some of the historical character of the old business district, the inescapably conspicuous evidence of newfound affluence is now seen in massive high-rises and residential teardowns.

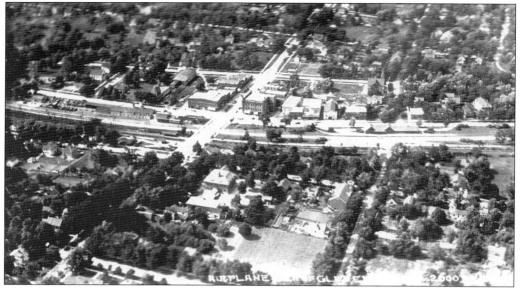

In this photograph, taken from an airplane around 1920, the trees are growing and so is the downtown business district. There is a new artificial ice plant on Crescent Boulevard, west of the DuPage County State Bank. Nadelhoffer's old frame stable is now surrounded by new masonry structures, while Pennsylvania Avenue remains largely undeveloped. Note the new Methodist church at Forest Avenue and Duane Street in the right foreground next to Jabez Dodge's house, moved from its original location on Main Street.

Main Street School was the third school in the Glen Ellyn District, serving the fast-growing new south side subdivisions. Built in 1920 on the southwest corner of Main Street and Hill Avenue, the school closed in 1982. The building was purchased and extensively renovated by the Glen Ellyn Park District and reopened in 1983 as the Main Street Recreation Center. It is now one of Glen Ellyn's most endangered historic buildings.

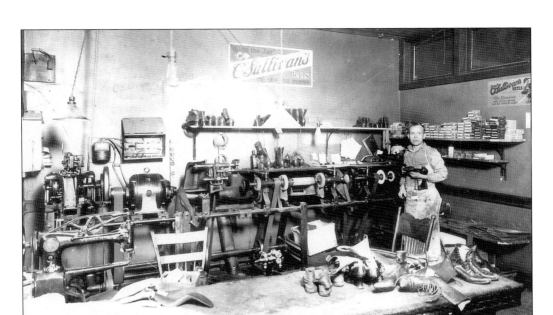

Glen Ellyn native Vak Sikler was as well known for the huge Christmas tree that he decorated in his front yard each year as for the shoe repair business that he operated for 25 years in the little space where undertaker John Kampp had practiced his art in the 1890s. John Hammond is the helpful little boy in this 1920 photograph. In 1951, Paul Herwaldt purchased the shop, and Paul's Shoe Service remains in his family today.

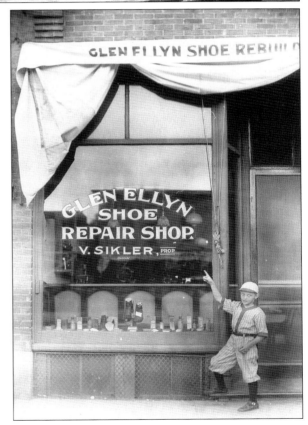

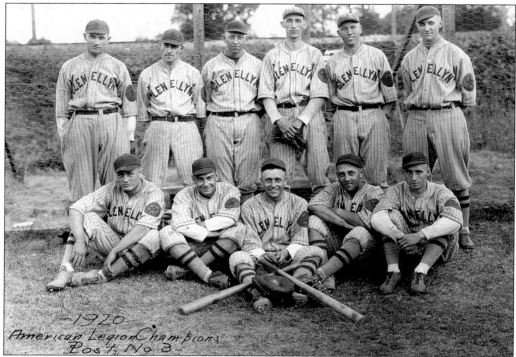

Pitcher Al Ludeke (third from right, standing) led the Glen Ellyn Reds to victory in 1920. Ludeke served in the First World War and worked for the Village Water Department for 30 years.

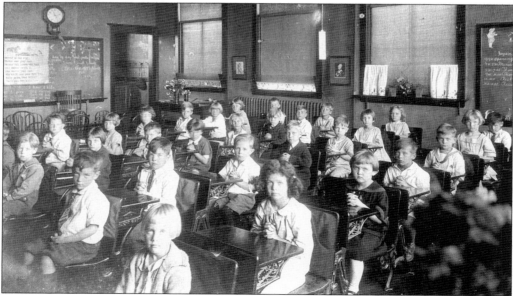

Mrs. Leitch's less than cheerful first-grade class poses politely at the old Hawthorne School in 1925. In the back row, under the window, is Helen Wagoner behind her friend Ellen Cooper.

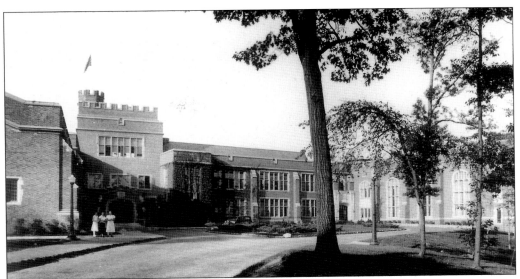

Glenbard High School was designed by Coolidge and Hodgdon, famed for their work on the Art Institute, the Chicago Public Library, and the University of Chicago. It was built in 1924 on five acres of land purchased for $8,000, including Honeysuckle Hill where the school stands and Lake Glen Ellyn, which diminished into Lake Ellyn when its south end was filled in to create an athletic field in 1922. Glenbard's magnificent collegiate brick and stone campus was featured, along with the Glen Theater and other local landmarks, in the 1986 film *Lucas*.

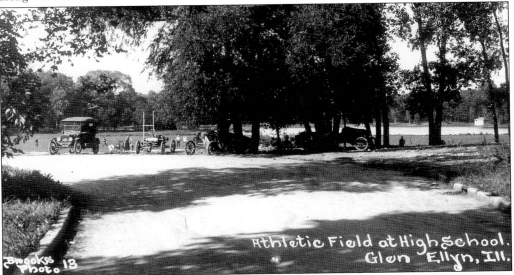

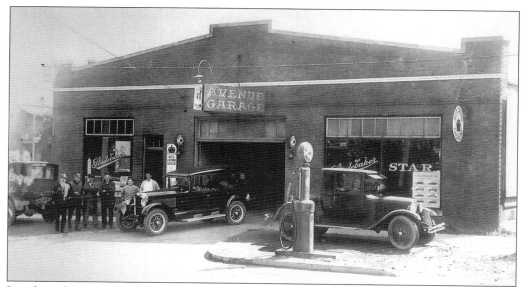

Joseph and Isaac Clarke, grandsons of pioneer Isaac Bradford Churchill, opened the Avenue Garage and Studebaker dealership on Pennsylvania Avenue across from the old firehouse in 1921. Seen here in 1925, it is still standing today, housing Ten Thousand Villages and other shops.

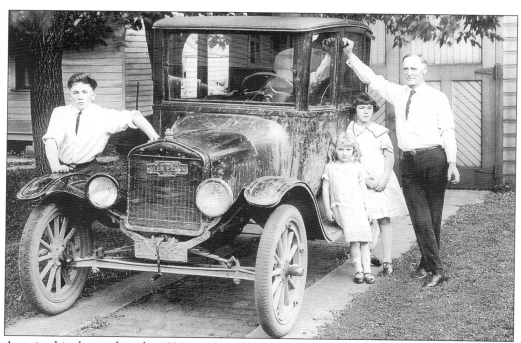

America hit the road in the 1920s, and no automobile carried more people than Henry Ford's famous Model T. This classic center door sedan, sporting a 1924 Glen Ellyn license plate, belonged to postmaster Joseph H. Wagoner, proudly posing here with his children, from left to right, Raymond, Helen, and Lois.

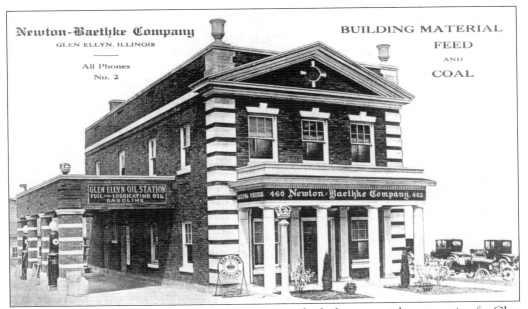

LeRoy Newton and William H. Baethke set a new standard of commercial construction for Glen Ellyn in 1924 with this fine office building on the site of the old Danby House. Shortly afterward, they sold the business to the growing Aurora-based Alexander Lumber Company.

There were 1,543 phones in Glen Ellyn in 1925 when this new telephone exchange opened on Pennsylvania Avenue. You lifted your handset and the operator asked, "Number, please?" If you said "Two," she would connect you to Newton-Baethke's office.

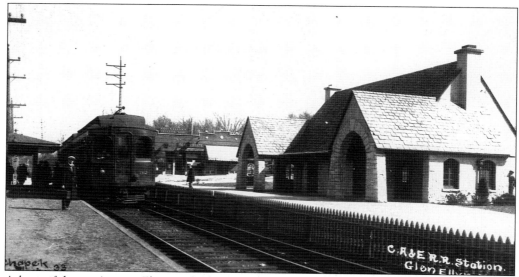

A beautiful new Aurora, Elgin and Chicago station was built in 1926, the same year architect John Archibald Armstrong designed the Talbot Hotel in Chicago. Unfortunately, the electric railroad shut down in the 1950s, and this gem was demolished in 1962 to make way for Glen Ellyn Savings, now Citibank FSB.

Miller Brothers Glen Ellyn Auto has become a Chalmers dealership next door to the Lathrop Brown Realty Building. Part of the open space between this building and the Ehlers Hotel will soon be filled with the first phase of the Glen Ellyn State Bank and Post Office.

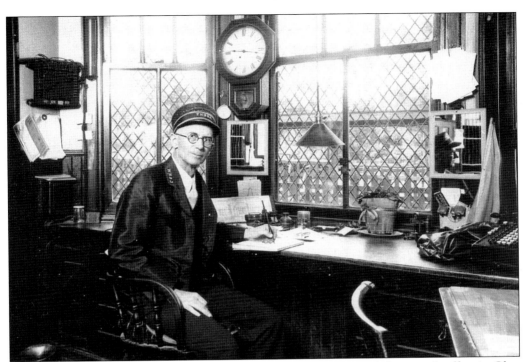

From 1927 until his retirement in 1942, Raymond Skinner occupied the agent's office in Glen Ellyn's Chicago and Northwestern Railroad station. The station grounds were much more extensive at the time, with parklike landscaping on both sides of the tracks extending from Park Boulevard to Main Street, now filled almost entirely with commuter parking spaces.

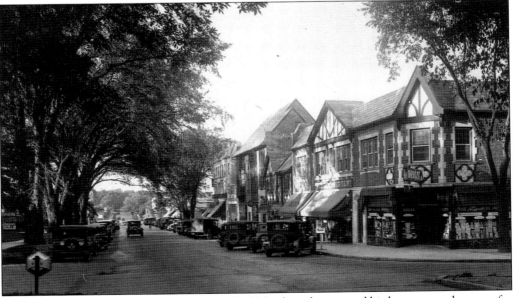

Orrin Dodge still kept a cow in his barn until 1926, when they moved his house to make room for commercial development on Main Street, south of Duane Street (see page 59). Horace Brooks planted the elm trees on the west side during the Civil War when this was part of his farm.

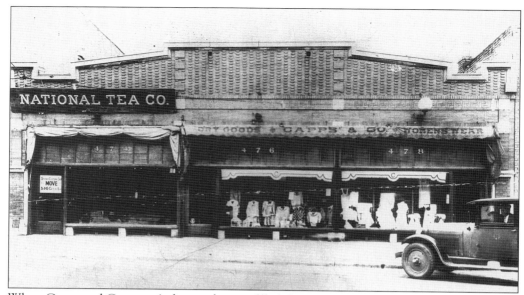

When Capps and Company's dry goods store filled the space between Boyd Brothers' 1892 and 1895 stores, the old creek was channeled underground in drainage tiles, where it still flows today, all the way to Lake Ellyn. Note the National Tea store's sign announcing its imminent move to Crescent Boulevard. With a remodeled facade, this building housed Johnny Wohl's Toys and Cards shop for many years.

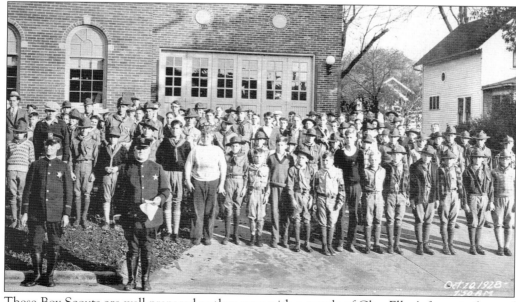

These Boy Scouts are well prepared as they pose with a couple of Glen Ellyn's finest in front of the village hall and fire department on a brisk autumn morning in 1928.

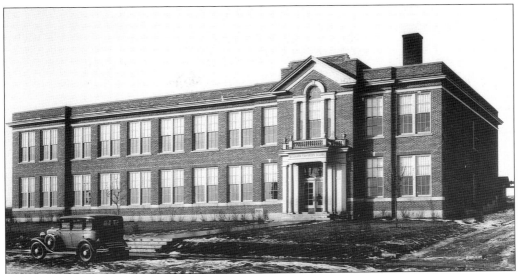

The Benjamin Franklin School, located on the old Jabez Dodge farm, was built in 1928. Greatly expanded but still in use at 350 Bryant Avenue, it was actually named after school board member Benjamin Franklin March.

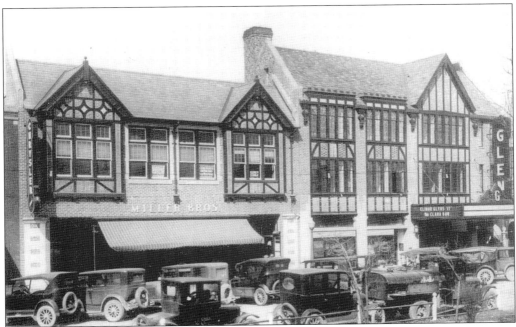

In was no easier to find a parking space on Crescent Boulevard in 1927 than it is today. Here Nadelhoffer's Livery has been replaced by a familiar village landmark, the Glen Theater—with its marquee featuring the silent film that established Clara Bow as the 'It Girl'. Note the recently remodeled Miller Brothers Chrysler dealership with second-floor apartments added in the requisite Old English style.

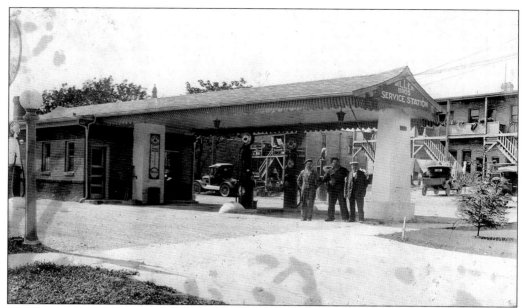

The Miller Brothers automotive business stretched from its sales and service building on Crescent Boulevard, next to the Glen Theater, all the way to Pennsylvania Avenue and this classic gas station. Long known to locals as Schock's Service Station, it is now commemorated by a minipark.

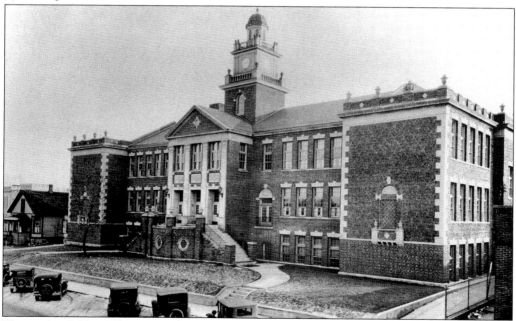

The pride of Glen Ellyn in 1929, this imposing junior high school building on the site of the old Duane Street School was designed by Frank Lloyd Wright student Norman Brydges. After the new junior high was opened in 1954, this building served the fifth and sixth grades. In the 1960s, its gymnasium hosted the youth center dances, and in 1972, it became the Glen Ellyn Civic Center.

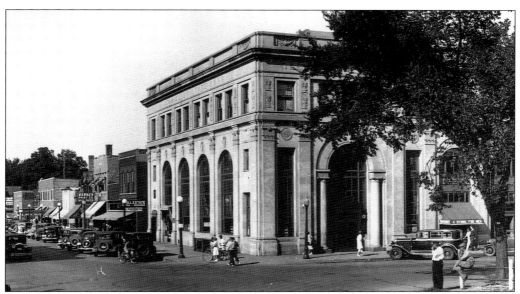

The Ehlers Hotel, built on the site of David Kelley's 1852 Mansion House, was replaced in 1929 by this gleaming symbol of new prosperity: the Glen Ellyn State Bank. The officers were a veritable who's who of Glen Ellyn civic leaders, including two McChesneys, the sons of L. C. Cooper, undertaker John Kampp, and Dr. Frank Johnson. They opened for business on September 7, 1929, and the stock market crashed in October. When the Dow Jones average bottomed out in the summer of 1932, the Glen Ellyn State Bank paid its depositors 50¢ on the dollar and closed its doors for good. It has since been known as the Professional Arts Building, housing a number of businesses, including the Village Herbalist.

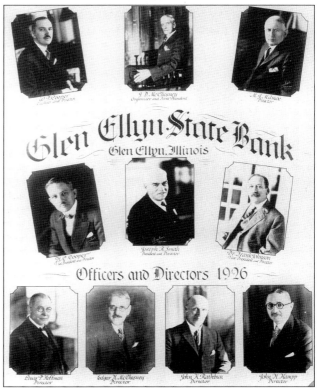

Ornithologist and world traveler Benjamin True Gault participated in scientific expeditions to remote places and searched out his roots in Ireland. He shared a passion for birds and trees with renowned ornithologist Dr. Robert Ridgway (right), with whom he is seen here in the yard of Ridgway's Olney home. Gault boarded with the Wagoners at 570 Anthony Street until shortly before his death in 1942. His vast, meticulously catalogued collections were stored in the attic of that house until 1964, when they were donated by Helen Ward to the Field Museum and the Morton Arboretum.

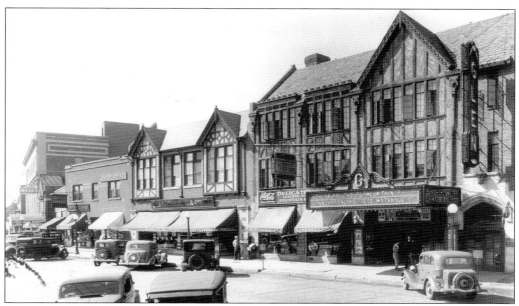

In these *c.* 1930 photographs, Miller Brothers has given way to the National Tea store (previously located on Main Street), and the new DuPage County State Bank building is complete. Brown's Real Estate is now a cigar store. As the corner is rounded onto Main Street (below), familiar storefronts are taking shape. The old Boyd Brothers store, now housing Heintz Drugs, has been remodeled, and on the right is Sears Roebuck and Warner Paint. The corner of the State Bank building has not yet been opened for Walgreen's entrance.

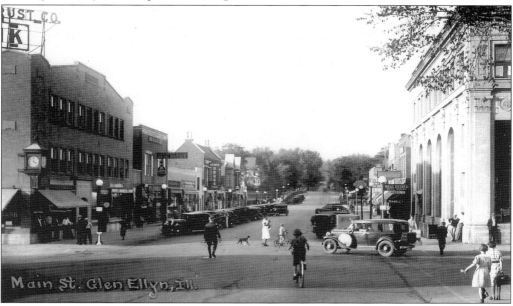

A true downtown Glen Ellyn landmark, the Flour Barrel Bakery has changed little since it was opened in 1930 by Ted and Berniece Boss.

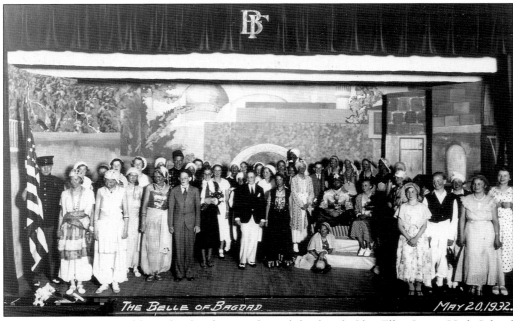

THE BELLE OF BAGDAD. MAY 20, 1932.

The new Benjamin Franklin School auditorium hosted this lavish Glen Ellyn Junior High School production of *The Belle of Baghdad* in 1932—the year Iraq emerged as an independent nation.

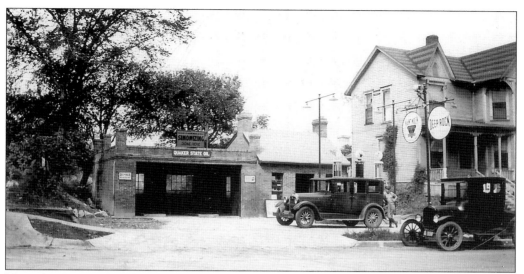

Hannah Wagoner had this Deep Rock service station built next to her home at 424 Main Street for her son William after he returned home from service in the First World War. Her grandson Raymond ran it as a Sinclair station in the 1930s before he went off to serve in World War II.

If one answered "25" when the operator said "Number, please?" this candlestick phone on Joseph H. Wagoner's desk would ring. He is seen here with his daughter Lois in August 1933, according to the Alexander Lumber calendar in this remarkably detailed photograph of his insurance and real estate office, located in a tiny building in front of his mother's home at 424 Main Street. The service station is visible through the window.

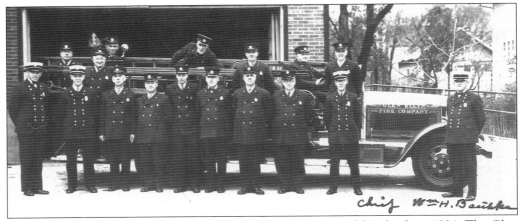

Fire chief William H. Baethke ran a tight ship for 23 years until his death in 1934. The Glen Ellyn Volunteer Fire Department proudly poses with Chief Baethke and their new ladder truck in front of the old firehouse in 1933.

These first-grade future firemen (and women) pose just as proudly in the very same year at Forest Glen School, which was built in 1909 on the site of the old Stacy's Corners school (see page 17). It was replaced with a new school across Main Street in 1950.

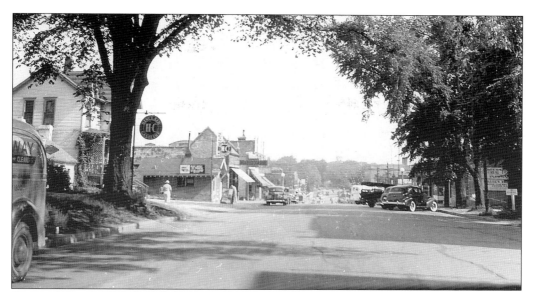

Some of Horace Brooks's elm trees still shaded Main Street between Hillside Avenue and Duane Street in 1937. Joseph H. Wagoner's little office building is on the left just past his son's Sinclair station.

One of downtown Glen Ellyn's architectural treasures is the 1934 post office, located on the site of 1878 postmaster Miles Allen's home on the northeast corner of Pennsylvania Avenue and Main Street. Remarkably, it is virtually unchanged and still in use by the U.S. Postal Service, with its lobby carefully preserved as it was when muralist and sculptor Dan Rhodes was commissioned by the Section of Fine Arts to paint *The Settlers*.

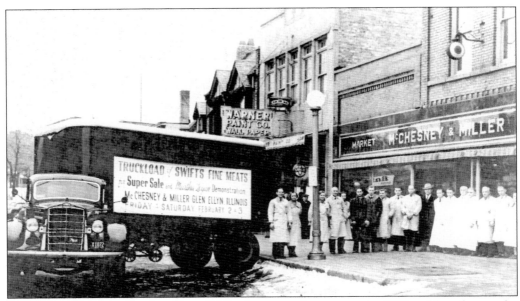

Charles McChesney's butcher Oscar Miller became a full partner in 1920 and bought out the McChesney family's interest in 1953. A major 1935 remodeling of the old 1892 Main Street store (now occupied by Christine's and the Book Store) is shown in the above photograph. Still owned by the Miller family, McChesney and Miller is now located at Crescent Boulevard and Glenwood Avenue. Below, Charles McChesney (left) and Oscar Miller pose alongside a pyramid of Shurfine peaches.

Classically trained musician and lifelong Glen Ellyn resident Helen Wagoner (center) performed with the Six Lovely Ladies in the Empire Room, the Chicago Theatre, the Boston Latin Quarter, New York, Detroit, Louisville, and other venues. After a Paramount screen test and an offer from Rogers and Hammerstein, she decided instead to marry U.S. Navy 2nd Lt. Donald C. Ward, who lived across the street, and to raise a family. (Thanks, Mom.)

The Lighthouse Restaurant and Mobile service station stood at the southwest corner of Roosevelt Road and Park Boulevard from 1932 until 1962, when Market Plaza was built. Col. Harland Sanders set up a franchise here in the 1950s with a handshake agreement that he would receive a nickel for every chicken sold using the secret blend of 11 herbs and spices that he provided from the back of his car.

PRINCE ICE CREAM CASTLES

* CONES * MALTEDS * CHILI

* SUNDAES * MILK SHAKES * HAMBURGERS

Where Glenbard Students Meet and Eat

Prince Castle stood across from the Duane Street School from 1929 until 1974. Earl Prince of Naperville invented a multispindled mixer for his "One in a Million" ice milk shakes. Chicago paper cup salesman Ray Kroc obtained the distribution rights for the Multi-Mixer from Prince in 1937. When the McDonald brothers ordered eight of the machines for their California hamburger stand in 1954, Kroc went there to observe their operations. The rest is history. The Glen Ellyn McDonald's, on Roosevelt Road since 1957, was one of the earliest. It was here that burger-flipping immigrant Luigi Salvaneschi, later president of Blockbuster Video, developed McDonald's first formal customer service training program.

The historic First Congregational Church of Glen Ellyn, started by Danby residents in 1862, was greatly expanded in 1928 with the addition of a sanctuary and bell tower, and again in 1960 with the addition of an education wing and a chapel named after benefactor Walter A. Rogers. This 1970s view shows the final result of a century of progress at Glen Ellyn's oldest church.

This photograph appeared in the November 1948 issue of *Better Homes and Gardens* as part of a feature on the renovated home that L. C. Cooper once called Birdwood. Mildred Heller (seen here) and her husband, Gene, bought the home at 545 Park Boulevard from renowned chemist Hermon Cooper (see page 113) in the early 1940s.

Anyone who lived in Glen Ellyn in the early 1960s will recognize the signs for Wohl's Toys and Cards, Heintz Drugs (forebear of Schimd Pharmacy), Sears Roebuck, Warner Paint, DuJardin's Books, Walgreen Drugs, and the DuPage Trust clock and its massive rooftop sign aimed at passing trains. With the addition of trees in sidewalk planters that might warm the heart of old Doc Johnson, the view remains very much the same today.

In the year 1900, in a house overlooking Lake Glen Ellyn, a baby girl was born. The music and laughter from the grand hotel and dance pavilion lulled her to sleep in the warm summer evenings. She walked on wooden sidewalks to the only school in town. For most of 46 years, she worked for Joseph H. Wagoner at the post office, in his insurance business, and in the office of township tax assessor, where she continued to work for another 24 years after Wagoner died in 1963. A widow with five children at age 40, manager of a large office at 85, with 14 grandchildren and 26 great-grandchildren at the age 105, Ann Bailey Prichard left this world on January 9, 2006, to join her childhood friends Mildred Patch Mulligan and Helen Myers Clippinger. All three died within five months of each other. (Courtesy of the Prichard family.)

AFTERWORD

Over the past 170 years, Glen Ellyn has known good times and hard times. Real estate booms have often, though not always, led to improvement, as in the delicate Victorian masterpieces of the 1890s or the classic Old English storefronts and magnificent masonry structures of the 1920s.

But every boom has been followed by a bust, including the post–Civil War recessions, the panic that punctured the Victorian real estate bubble, the devastating Great Depression, and the inflationary 1970s. Glen Ellyn has survived all of these, and they have made this community stronger and better. Those who look at the big picture, who care deeply about both the past and the future, understand that prosperity can sometimes present a different sort of challenge.

Like many affluent American suburbs, Glen Ellyn is riding the crest of a wave that has inflated the value of in-town residential lots to the point that sound, architecturally unique and often historically significant homes are being demolished or radically altered to create nonconforming super-sized infill structures on undersized lots that disturb the spacious and eclectic character of long established residential neighborhoods. Owners are openly solicited by companies that specialize in teardowns, while rising assessments make it increasingly hard for subsequent generations to hold on to heirloom family homes.

While the fashion and marketability of oversized houses can change overnight, the desirability of Glen Ellyn's traditional neighborhoods, so long as they retain their open space and architectural diversity, can only increase. It is the author's hope that by calling attention to the genuinely historic past of this community, this little book might help to encourage residents to look at the big picture and to get involved in shaping a better future for the village of Glen Ellyn.

The Glen Ellyn Historical Society Board of Directors, 2006, include (first row) Ruthann Ward, Jeanne Enright, Marge Teiwes, Jan Langford, and Bob Chambers; (second row) Weldon Johnson, Jean Jeske, Karen Olson, Earlene Merrick, Ruth Wright, and Judy Johnson; (third row) Doug Ward and Pres. Bill Peterson. Not pictured is Ellie Caviale.

The Glen Ellyn Historical Society was founded in 1968 to partner with the village of Glen Ellyn in restoring the Stacy's Tavern building as a historic museum. Since its opening on July 4, 1976, the society has managed the museum as a learning and tourist center for the village.

Volunteers operate the museum, history center, and archives, providing educational programs for school children and adults, including discussion groups, special exhibits, and first-person portrayals. In 1999, the society published an expansive illustrated history of the village, *Glen Ellyn: A Village Remembered*.

The first DuPage County building listed on the National Register of Historic Places, Stacy's Tavern is the only fully restored Illinois stagecoach inn of its period still on its original foundation. In partnership with the village of Glen Ellyn, the society is developing a community history park that will feature a number of historic Glen Ellyn buildings, including Stacy's Tavern Museum, period gardens, and ample parking. Additional information is available at the Glen Ellyn Historical Society Web site.

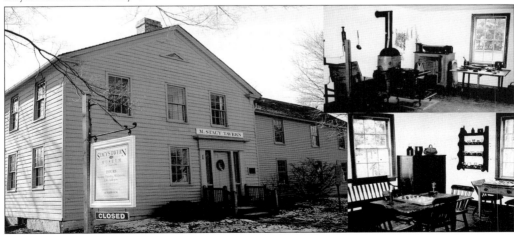

BIBLIOGRAPHY

1874 Atlas & History of DuPage County. Wheaton, IL: DuPage County Historical Society, 1975.

Cooper, L. C. *Reminiscences of Old Glen.* Glen Ellyn, IL: Originally published in the *Glen Ellyn News,* 1922–1923. Transcribed, prefaced, and indexed by Frederick S. Weiser in 1957.

Harmon, Ada Douglas. *The Story of an Old Town – Glen Ellyn.* Glen Ellyn, IL: Glen News Printing Company, 1928.

Kaiser, Blythe P., and Dorothy I. Vandercook. *Glen Ellyn's Story.* Dorothy I. Vandercook, 1976.

Kroc, Ray. *Grinding It Out: The Making of McDonald's.* New York: St Martin's Press, 1990.

Moody, Walter D. *Wacker's Manual of the Plan of Chicago.* Illinois: Chicago Plan Commission, 1916.

Schmidt, Royal J. *The Potawatomi Indians of DuPage County.* Wheaton, IL: DuPage Historical Society, 1974.

Turner, Glennette Tilley. *The Underground Railroad in DuPage County, Illinois.* Wheaton, IL: Newman Educational Publishers, 1986.

Ward, Helen W., and Robert W. Chambers. *Glen Ellyn: A Village Remembered.* Glen Ellyn, IL: Glen Ellyn Historical Society, 1999.

Weiser, Frederick S. *Village in a Glen.* Glen Ellyn, IL: The Anan Harmon Chapter, National Society of Daughters of the American Revolution, 1957.

ACROSS AMERICA, PEOPLE ARE DISCOVERING SOMETHING WONDERFUL. *THEIR HERITAGE.*

Arcadia Publishing is the leading local history publisher in the United States. With more than 3,000 titles in print and hundreds of new titles released every year, Arcadia has extensive specialized experience chronicling the history of communities and celebrating America's hidden stories, bringing to life the people, places, and events from the past. To discover the history of other communities across the nation, please visit:

www.arcadiapublishing.com

Customized search tools allow you to find regional history books about the town where you grew up, the cities where your friends and family live, the town where your parents met, or even that retirement spot you've been dreaming about.